Matthias Arnold

HENRI DE TOULOUSE-LAUTREC

1864–1901

The Theatre of Life

Benedikt Taschen

FRONT COVER:
Detail from: **Poster for singer Aristide Bruant, 1893**
Coloured lithograph, 127 x 95 cm
Museum für Kunst und Gewerbe, Hamburg

FRONTISPIECE:
The Clowness Cha-U-Kao at the Moulin Rouge, 1895
Oil on canvas, 75 x 55 cm
Oskar Reinhart Collection, Winterthur

BACK COVER:
Henri de Toulouse-Lautrec

**This book was printed on 100% chlorine-free bleached
paper in accordance with the TCF standard.**

© 1993 Benedikt Taschen Verlag GmbH
Hohenzollernring 53, D-50672 Köln
Edited by Ingo F. Walther
English translation: Michael Hulse
Cover design: Angelika Muthesius, Cologne
Printed by Druckhaus Cramer GmbH, Greven
Printed in Germany
ISBN 3-8228-9641-1
GB

Flautrec

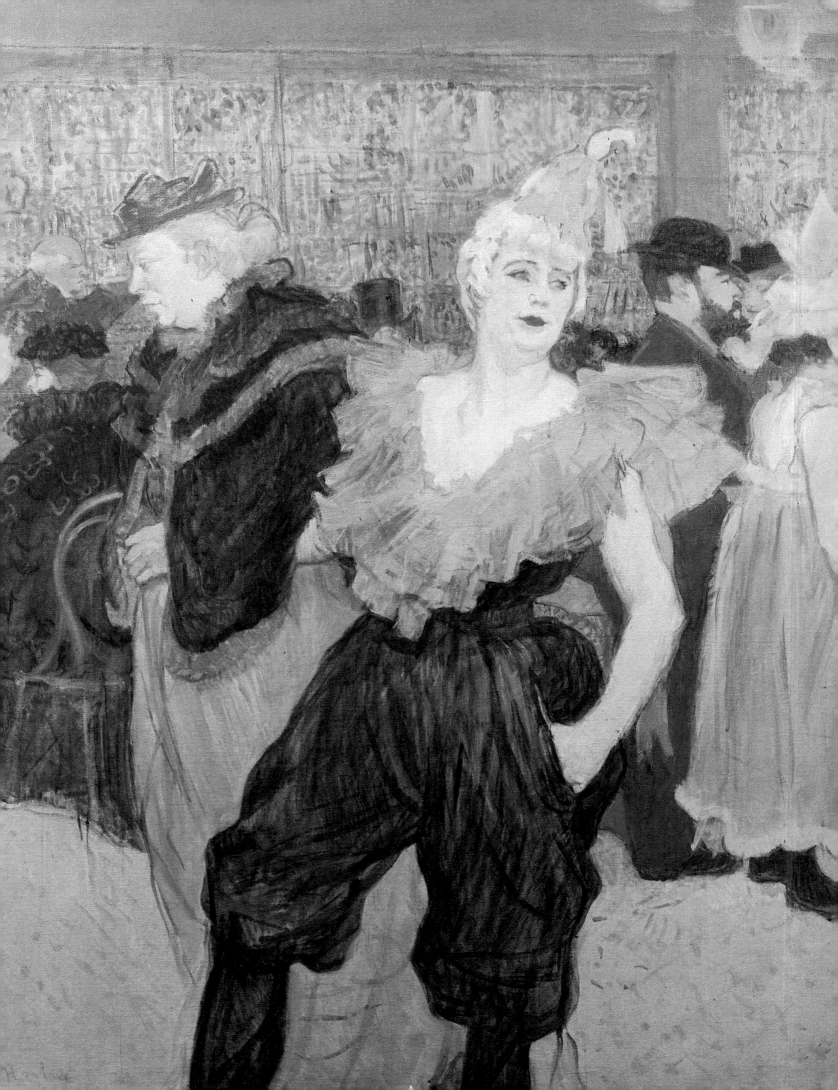

Contents

Problems, and How to Inherit Them
1864 - 1885

An early and virtuoso self-portrait of a great artist: a young man is seen standing somewhat apprehensively looking into a mirror (left). The entire inventory of his feudal family home, at once costly and irrelevant, has been built up like a barricade between himself and his image – and the artist himself appears to have become part of the still-life. The light touches only his back and the nape of his neck. His face is in shadow. It is as if the young painter were reluctant to show it to the viewer or to himself, and the message is clearly one of self-doubt and scepticism: Is painting really my vocation? Will I make it? What about my body? Why have I been so terribly cursed with withered legs and a face that grows ever more ugly, with thick red lips and a weak chin which a first growth of beard is at last beginning to give some cover to? The man who posed these questions in his painting stood on the threshold of a unique career that was to establish him among the major artists in history. His name was Henri de Toulouse-Lautrec. And he was about to make his great leap from a cloistered dynastic background to the easy-going world of Parisian pleasures.

The counts of Toulouse can trace their family back to the times of Charlemagne, and they played a prominent part in the Crusades, but by the 19th century they were no longer making any kind of important contribution to the course of history. Instead, they were living an isolated life of plenty at their various estates in the south of France. It was a life of wealth and leisure, of hunting, animal breeding, party-giving, and musical dilettantism. To keep the family fortune as intact as possible it had long been tradition for relatives to intermarry within the family, and this, along with the agreeable financial advantages, brought with it rather less agreeable problems of genetic inheritance.

Count Alphonse de Toulouse-Lautrec-Monfa married Countess Adèle Tapié de Céleyran on 9th May 1863. Their mothers were sisters, the count and countess first cousins, and their marriage therefore tainted with the familiar incestuousness. It is worth mentioning that the bride's brother and the bridegroom's sister similarly entered on a union of this problematic nature, and paid for it with a number of still-born or mentally retarded children who were referred to in family correspondence, with a belittling kind of reticence, as "weak" or

**Page from a school exercise book,
ca. 1876–1878**
Pen, 23 x 18 cm
Musée Toulouse-Lautrec, Albi

"To think I would never have painted if my legs had been just a little longer!"
TOULOUSE-LAUTREC

LEFT:
**Self-portrait at the mirror,
ca. 1880**
Oil on cardboard, 40.3 x 32.4 cm
Musée Toulouse-Lautrec, Albi

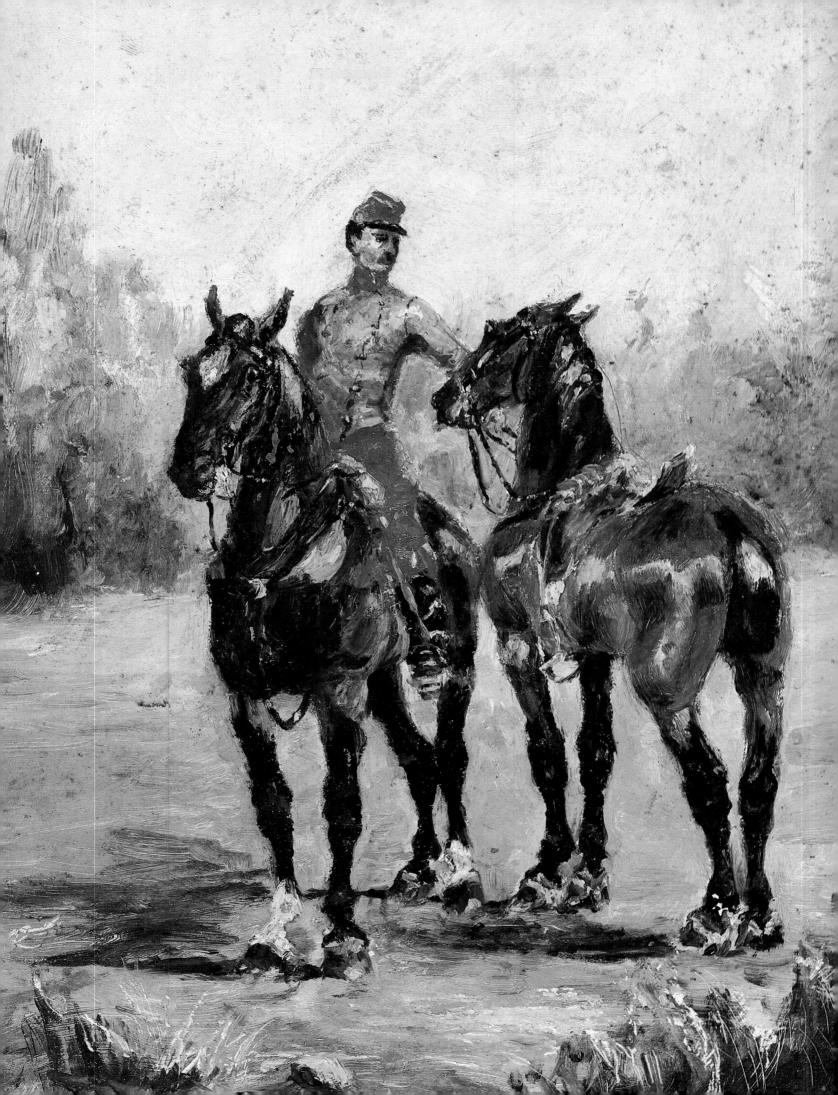

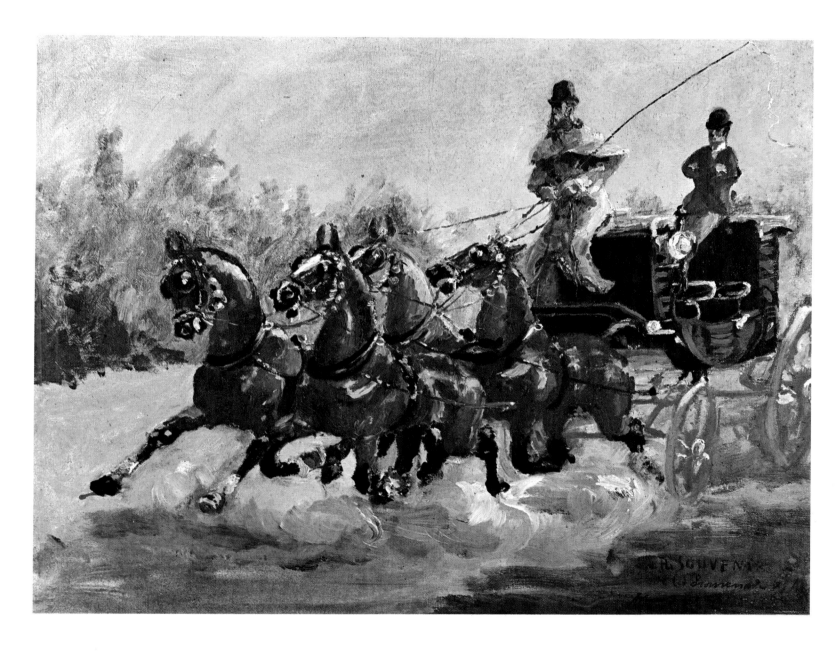

"susceptible". As for Countess Adèle, on 24th November 1864, at the Hôtel du Bosc at Albi (the family's mediaeval town residence), she gave birth to a first child, a son, who was named Henri. A second son born four years later died at one year old.

The two cousins' illusions were also short-lived. Their marriage was one of convenience; and soon the differences in their characters drove them to go their separate ways, though the formal bond remained. Henri was brought up by his mother, who coped with the loss of her second child and the failure of her marriage by seeking refuge in the Catholic faith and in caring for the little son that was left to her. For a long time, commentators portrayed Countess Adèle in a too rosy light, as a self-sacrificing and loving (albeit rather bigoted) mother who did everything she could for her Henri. However, family letters which had evidently long been suppressed and which have only recently come to light tell a different story: of a woman close to religious mania, a

Count Alphonse de Toulouse-Lautrec Driving His Mail Coach in Nice, 1881
Oil on canvas, 38.5 x 51 cm
Musée du Petit Palais, Paris

LEFT:
Groom with Two Horses, 1880
Oil on cardboard, 32.5 x 23.8 cm
Musée Toulouse-Lautrec, Albi

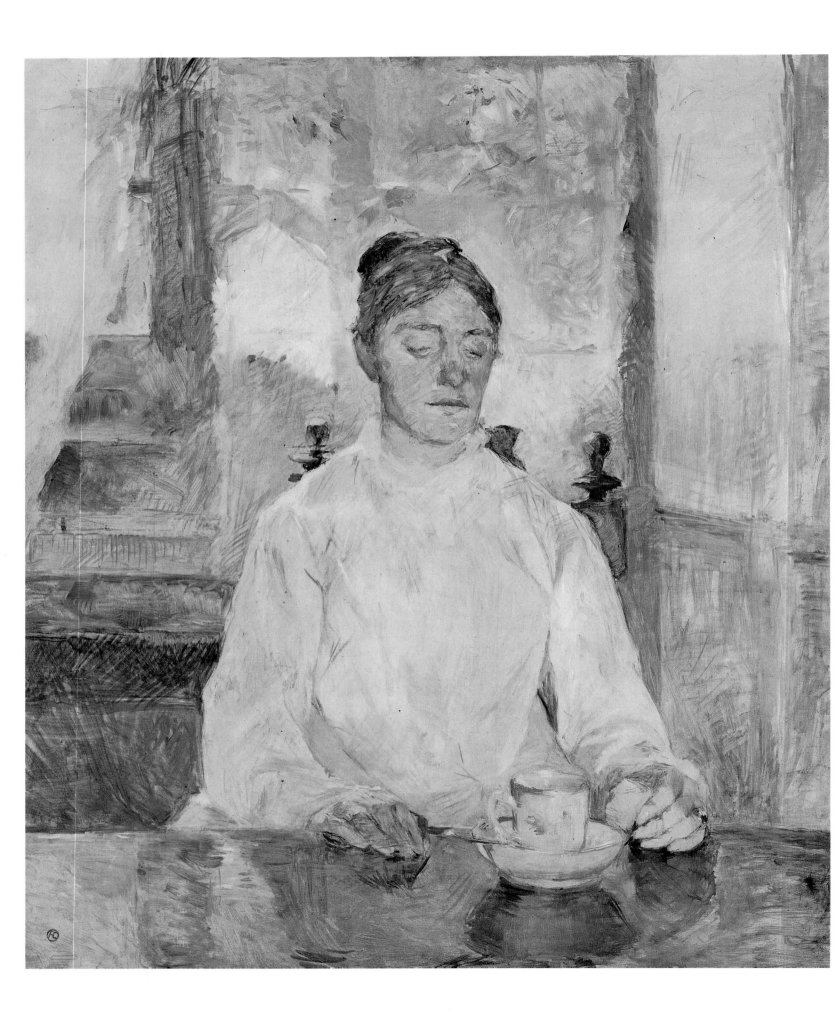

hypochondriac and clinically hysterical, and in practical affairs with a good business head but mean. Her one real mistake was her passing love for Count Alphonse. Even her son, who loved her dearly, came to see this fact in the course of time: "My mother, Virtue personified! But she couldn't resist those red cavalry trousers!" (He is referring to the officer's uniform his father wore.)

For the young Henri, Countess Adèle was the most important person in his life; at times, on account of his weak constitution, she tutored him herself, and in all things he was the apple of her eye. Inevitably, as the child later grew to manhood, motherly dominance and care as problematic and oppressive as Countess Adèle's prompted reactions and the attempt to achieve the independence the young Henri had been denied. Toulouse-Lautrec's extreme career, from elitist aristocracy in the family château to the bohemianism of Montmartre cabarets and clubs, is perfectly understandable if we bear this background in mind: if he was to find himself and make his own way, the son had to put his possessive, didactic mother well behind him. Toulouse-Lautrec's dive into the bright world of the belle époque has hitherto been viewed as a consequence of his physical shortcomings, and no doubt they played a part, but psychologically it is likely that the need for emancipation from the maternal superego was of even greater significance. In order to find himself, Toulouse-Lautrec was prepared to go to any lengths, and ultimately even self-destruction. There was hardly any alternative.

Count Alphonse has traditionally been portrayed as a forceful and quaint eccentric, and doubtless the image is correct. But he may well have been the more natural, sensual figure in this disrupted family, all the subjectively-coloured reports to the contrary notwithstanding. In addition he was given to erotic dissipation, and had a passion for hunting that was almost grotesque. When Henri was twelve, his father gave him a book inscribed with words that the boy was to remember later in his worst health crisis: "Always remember, my son, that the only truly healthy life is a life out in the daylight and open air. Whatever is robbed of its freedom withers away and soon dies. This little book on falconry will teach you to value life out in the free open spaces of Nature. If ever you should become acquainted with the bitter side of life, a horse will be your best friend, and your dog and falcon will stand by you too, all of them loyal companions to help you overcome the injuries you suffer."

Henri no doubt inherited his father's unbridled temperament but nevertheless was later to eschew life out in the daylight and open air just as thoroughly as he rejected the kind of life advised by his mother. He put up deliberate opposition to his father too, though for different reasons. Count Alphonse rejected his son out of disappointment over the physically weak and retarded constitution of the boy, which would forever prevent him being the kind of horseman, hunter and soldier as he himself was. This must have hit young Henri hard, since he dearly loved horses, dogs and other animals; it may well have been a more

**The Artist's Mother,
Countess Adèle de Toulouse-Lautrec,
ca. 1883**
Charcoal, 62 x 40 cm
Brooklyn Museum, Brooklyn (N.Y.)

LEFT:
**The Artist's Mother,
Countess Adèle de Toulouse-Lautrec,
at Breakfast at Château Malromé,
ca. 1881–1883**
Oil on canvas, 93.5 x 81 cm
Musée Toulouse-Lautrec, Albi

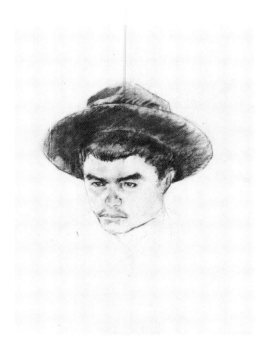

Young Routy at Céleyran, 1882
Charcoal, 63 x 48 cm
Musée Toulouse-Lautrec, Albi

"All day I am very much on my own, I read a little but if I keep it up for long I get a headache. I draw and paint as much as I can without tiring myself out, and when it grows dark I wonder if cousin Jeanne d'Armagnac will come to my bed! Sometimes she turns up and wants to play with me, and I listen to the things she says, but I am unable to look at her. She is so tall and handsome! And I am neither tall nor handsome." TOULOUSE-LAUTREC

Young Routy at Céleyran, 1882
Oil on canvas, 61 x 51 cm
Musée Toulouse-Lautrec, Albi

bitter pill to swallow than the realisation that physically he was not up to scratch.

At the ages of thirteen and fourteen, Henri broke first one leg and then the other in accidents, and confirmed what had already been apparent but had been ignored by the family as long as possible or glossed over: the lad was suffering from a hereditary bone disease (pyknodysostosis), the major symptoms of which became evident around the age of ten. All his life long, Toulouse-Lautrec's bone structure remained sensitive and weak. After the first leg had been broken, in 1878, Countess Adèle tried cures and other more dubious methods of healing; but Henri's fractured thighbone was probably not treated as well as it might have been, and all the cures and other methods were of no avail. His legs stopped growing. As a youth, then as a man, Toulouse-Lautrec never grew taller than 152 cm (5' 1").

Lengthy spells in a sanatorium, and enforced rest and reclining, were very boring for a boy, but they had one positive side effect. Since he was six, he had shown an obvious talent for drawing, and now it became even more developed. While he was waiting in vain for the wished-for recovery, he filled school exercise books, sketch books, and any scraps of paper he could find, with drawings of everything that came into his head, whether he had seen it or only imagined it – people and animals, mainly. What drawings are preserved from Toulouse-Lautrec's childhood show that he was no prodigy but nonetheless plainly talented. This talent was not, however, rated any higher than a pastime. Toulouse-Lautrec's father, and his uncles Charles and Odon, all dabbled in painting as a hobby, and for the men of the aristocracy hunting, drawing and gourmet eating were all essential pleasures. As Toulouse-Lautrec's grandmother once put it: "When my sons shoot a wild duck they take a threefold pleasure in it: with their guns, their pencils, and their forks."

The fourteen-years-old's first oil paintings show the family property, a hunting and courtly milieu with horses, carriages, riders and dogs. A deaf-mute friend of Henri's father, René Princeteau, who specialized in painting animals, introduced the boy to the rudiments of painting when he was staying in Paris, and this teacher's speciality, together with Henri's own love of animals, naturally determined the choice of subjects in these early paintings. If the lad could not ride horses well, at least he was going to paint them well! It may be that these pictures were also a means of impressing his father.

It took Henri two tries and great effort, but in November 1881 he passed the first part of his school-leaving exams and, now aged seventeen, decided to lose no time. He wanted to be a painter. When we read the biographies of artists we often find parents offering fierce opposition, but in the case of Toulouse-Lautrec this was not so, and when later he had trouble with his family it was not because he was a painter but because of his choice of subjects and treatment. Initially, of course, the pictures the young artist showed his family were of horses and dogs, and scarcely likely to ruffle an aristocratic milieu.

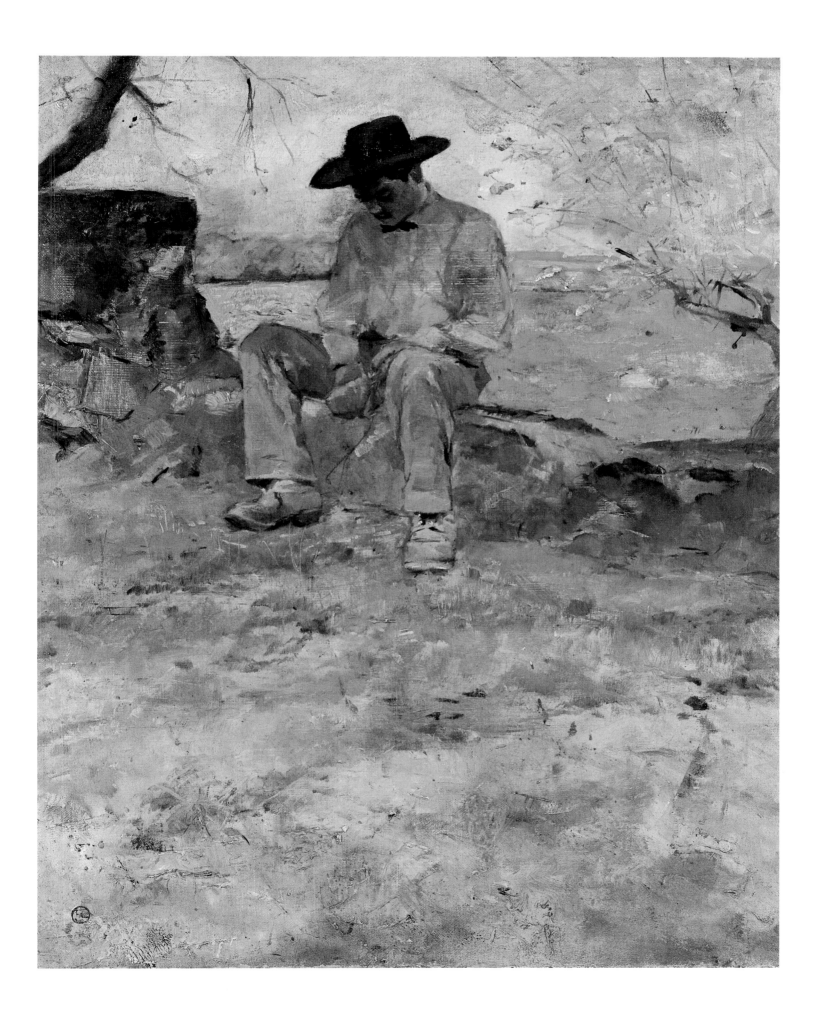

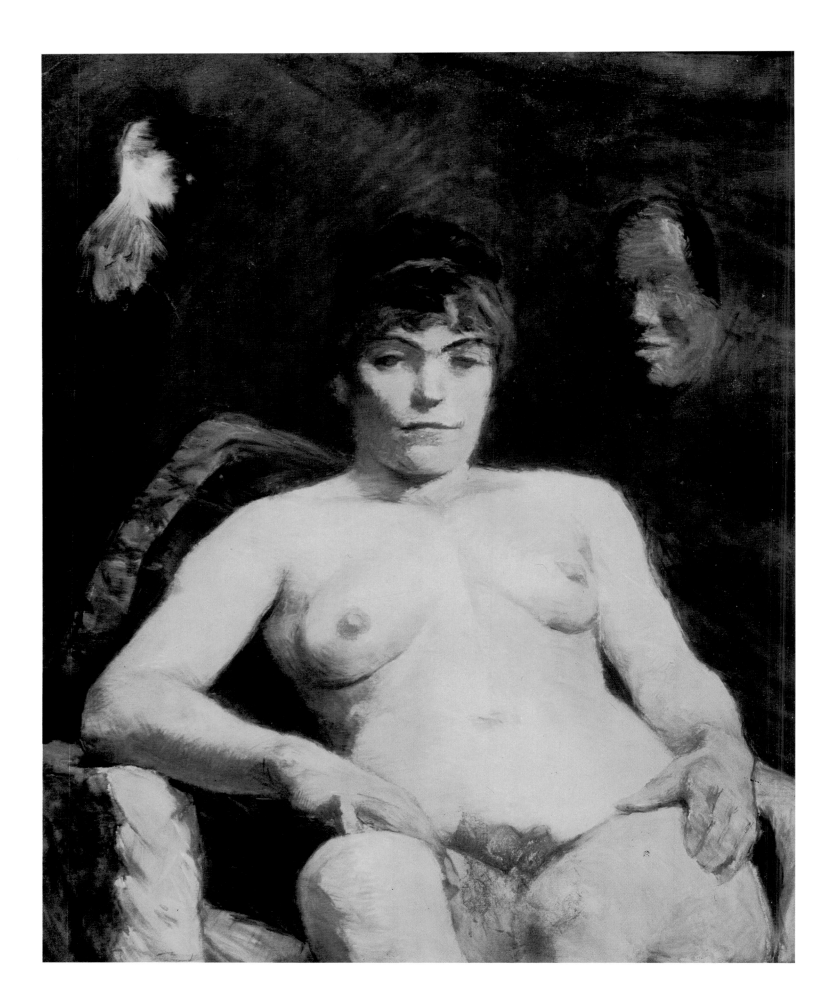

Count Alphonse consulted his painter friends Princeteau, John Lewis Brown, and Jean-Louis Forain, and they advised that his son needed academic training. On Princeteau's recommendation, and the personal introduction of Henri Rachou, a fellow-Albingensian, Toulouse-Lautrec entered the Parisian studio of Léon Bonnat, a fashionable painter, on 17th April 1882. A few weeks later, the young art student reported Bonnat's comments on his work as follows: "He told me: 'Your paintings are not at all bad, which is splendid, but, well, it just means they are not at all bad, and as for your drawings they are atrocious!'" Not many years later, Bonnat was to pronounce a similarly unfair judgement on his pupil Edvard Munch. In 1882, it is true, Toulouse-Lautrec was by no means mature as an artist; but his work at that date gives unmistakable evidence of great talent both as painter and as draughtsman. In later years, Bonnat was to stick to his antipathy towards his former pupil.

We need hardly be surprised that when Bonnat, not long afterwards, was given a position at the Ecole des Beaux-Arts, he did not take his unfavoured pupil to his classes there. So Toulouse-Lautrec found himself looking for a new teacher. The new teacher was Fernand Cormon, a salon artist who (like Bonnat) is now of no importance but who was at least of a more liberal disposition. "Above all," Toulouse-Lautrec wrote home, "he likes my drawings." And so the young artist was confronted with two totally contradictory academic opinions in the space of a few months. Not that this new praise was incentive enough: "When Cormon corrects me, he does it in a much gentler fashion than Bonnat; he takes a look at everything you show him and is very encouraging. You may be baffled by this, but in fact I find it less to my taste. When my first boss lashed me, the lashes hurt, and I didn't spare myself. But here I feel weakened and I need courage to produce a well-crafted drawing when a less good one would satisfy Cormon just as easily."

Naturally the young student submitted to the regulations and conventions of the academy, albeit only pro forma; but evidently he had his own ideas about painting and drawing right from the start. Beginning with his earliest oils, we are confronted with a technique and free artistic approach that are the very opposite of what then prevailed in the salons. Princeteau, Brown and Forain, as well as (from an early stage) the Impressionists, exerted a far stronger influence than Bonnat or Cormon. The paintings Toulouse-Lautrec did around 1880, as a sixteen-year-old, are composed in so easy-going and unconventional a manner that we can see them without reservation as his first wholly independent works (p. 8).

His pictures of horses, so dynamically expressive and with an energy in the brushstrokes that he may have learnt from Eugène Delacroix, show Toulouse-Lautrec already adept at what was later to become his unique hallmark: the recreation of a spontaneous, forceful and characteristic moment. The painting of his father in control of a brisk four-in-hand (p. 9) can meaningfully be compared with the artist's later

"Yes, what disturbed me especially was his disorderly form. Poor Henri! Every morning he came to my studio; at the age of 14, in 1878, he copied my studies and painted portraits; mind you, I trembled with horror. During the vacation he painted portraits, horses and dogs from nature, and soldiers on manoeuvre. During the winter, in Cannes, he painted ships, the sea, and women horseriders. Henri and I would go to the circus together on account of the horses, and to the theatre because of the decoration. He knew a great deal about horses and dogs." RENÉ PRINCETEAU

"Perhaps you are not aware of Bonnat's way of encouraging me. He told me: 'Your paintings are not bad – which is fine, though it still means they are simply not bad – but your drawings are utterly appalling.' And then you have to take your courage in both hands and start again: onward, breadcrumb!…" TOULOUSE-LAUTREC

"Cormon gave me a favourable reception. My drawings appealed to him best of all. My new master is the thinnest man in all Paris. He often comes to see us, and prefers us to paint outside the studio as often as possible." TOULOUSE-LAUTREC

Fat Maria, 1884
Oil on canvas, 80.7 x 64.8 cm
Von der Heydt Museum, Wuppertal

The Laundress, 1888
Charcoal, 65 x 50 cm
Musée Toulouse-Lautrec, Albi

"Nothing for it, nothing for it, I must play the deaf mute and batter my head against the walls – yes – and all for an art that eludes me and will never encompass all the terrible things I have endured for its sake… Ah, dear grandmother, you are wise not to give yourself over to painting as I do. It is more awful than Latin if you take it as seriously as I do." TOULOUSE-LAUTREC

The Laundress, 1884
Oil on canvas, 93 x 75 cm
Private Collection, Paris

obsession with dance movements. The background, rendered as if it were coloured cotton wool, is merely a backdrop in such paintings. The young Toulouse-Lautrec painted charming, sketchy landscapes in his home region, landscapes that are marked by a very vigorous technique, patches of colour linked up at lightning speed and tree-trunks or outlines gouged out of the paint with the handle of the brush. They are deeply-felt, visionary images of Nature, and we must almost regret the artist's later concentration on the human figure.

Subsequent to the early self-portrait, Toulouse-Lautrec repeatedly produced successful portraits of people in his immediate circle: Countess Adèle, for example, patiently sat for her son again and again. There are few painters who have paid such artistic homage to their mothers. The light-coloured portrait of his mother (p. 10), done in a virtuoso Impressionist style, is particularly good at conveying not only a quiet moment at the coffee table but also the mother-fixation of the young painter. The sparing use of colour – the concentration on bright, creamy shades of yellow and brown, with a few reddish and greenish highlights – already announces the delicacy of colour that was always to be at Toulouse-Lautrec's disposal.

In 1882 Toulouse-Lautrec portrayed a young farmworker called Routy (p. 13), who worked on the Céleyran estate, sitting on a low garden wall and carving a piece of wood. It is an unusual composition: the lower portion consists purely of a ground loosely applied (ploughed, as it were) with brush and spatula, and if it were not for the figure and landscape in the upper half it could be an abstract painting. This creates a kind of spatiality that draws our attention all the more strongly to the young man. The figure, and the landscape visible in the background too, has been done in broad patches of colour, and the painting dispenses almost entirely with outline. What results is a colour harmony in adjacent shades of grey, blue and green, with the odd highlight in brown. A number of preliminary drawings preceded this composition (p. 12), as indeed did another painting of young Routy out in the open, a half-length portrait which is qualitatively quite the equal of our picture and which is now in the Neue Pinakothek in Munich.

In 1884 Toulouse-Lautrec did a large-scale parody of the idealistic mural "The Sacred Grove" by Pierre Puvis de Chavannes, then much in demand. This parody was the twenty-year-old artist's farewell to that hollow, lying art of officialdom and bourgeois salons which was being imposed on him as an example to be followed. That same year, at least in terms of his domicile, Toulouse-Lautrec began to cut the apron strings and establish a circle of his own, friends and work that had nothing to do with his mother. He sensed the need of this, though it was not easy. What he wrote to his family was perhaps not wholly the fact of the matter: "Of course Papa would think me an outsider... It has cost me an effort, and you know as well as I do that leading a Bohemian life goes against the grain and taxes my will sorely in the attempt to get used to it, since I still bear with me a load of sentimental considerations that I shall have to throw overboard if I am to get anywhere..."

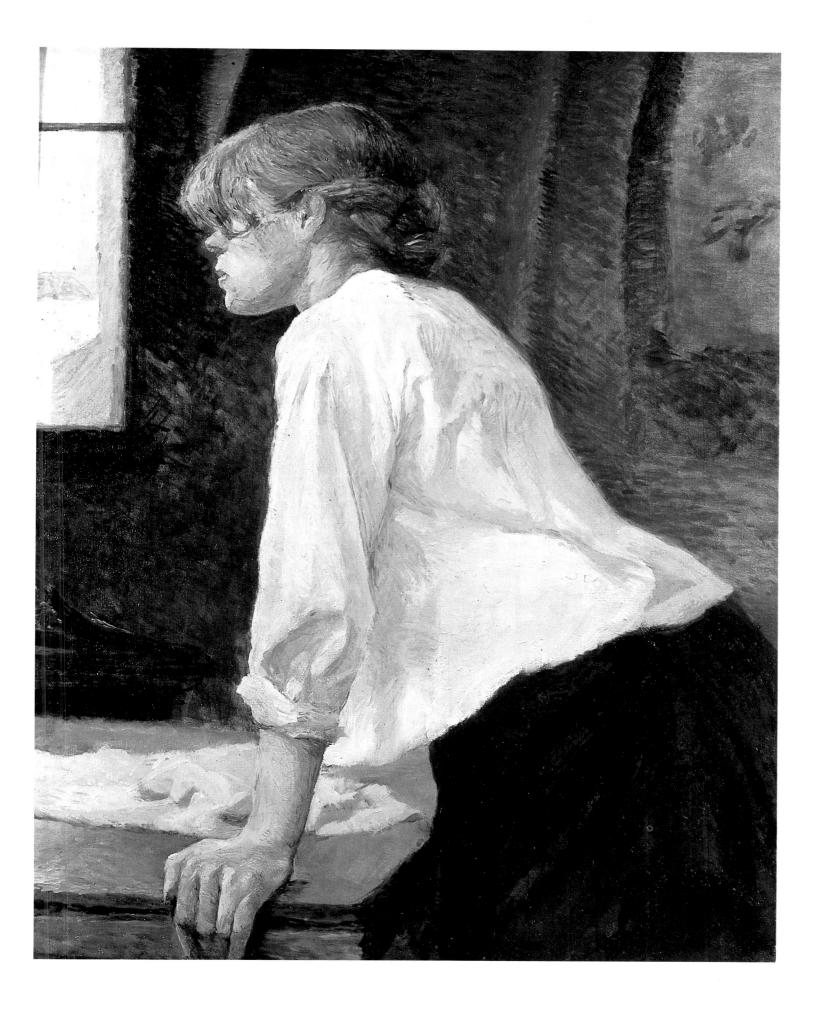

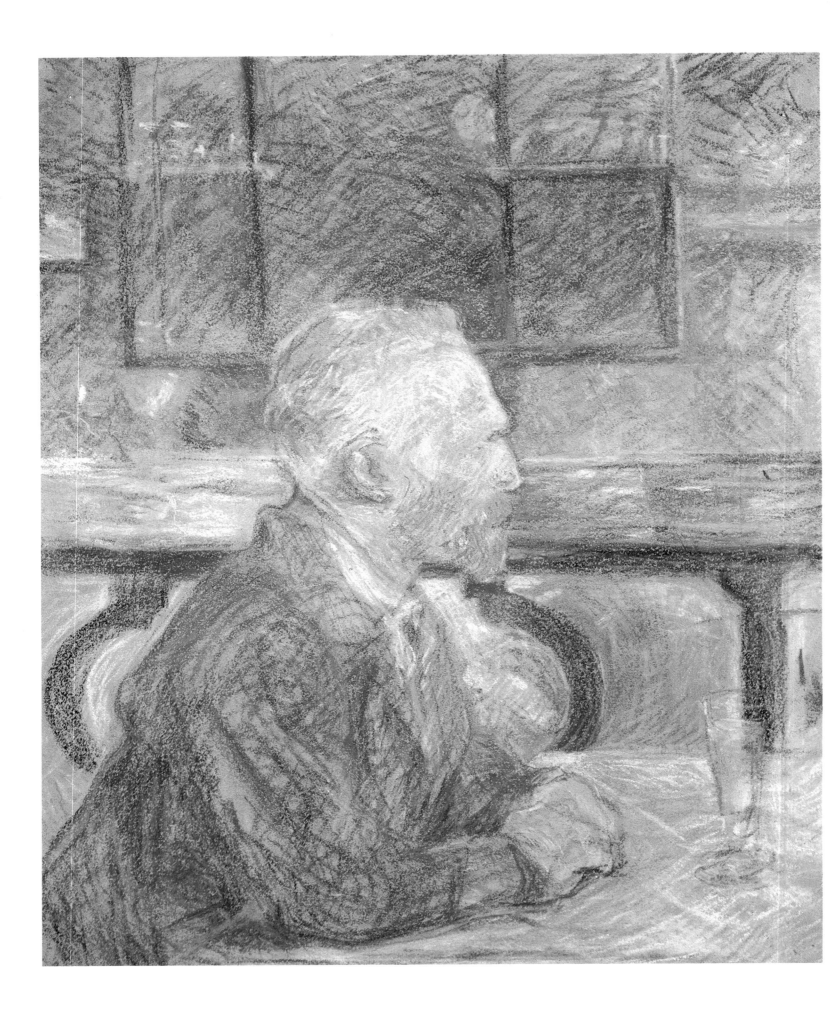

A New Style
1886 - 1891

A bar in Paris. Toulouse-Lautrec is twenty-three. Across from him sits his fellow-artist Vincent van Gogh, aged thirty-four – and with a few feeling strokes of his chalk the younger man produces what is far and away the most sensitive and revealing portrait we have of the Dutch painter (left). This is how others saw the passionate van Gogh: as an animal sitting in wait, with his absinthe, at a table, ready to spring at any moment. Van Gogh's self-portraits have their own expressive and artistic power, but this portrait by Toulouse-Lautrec is a masterpiece of psychological insight in its recreation of the phenomenon we label "van Gogh". It is the first time we find the young Frenchman's empathy giving us a full, essential human image. The style of the picture is still Impressionist, but its content goes far beyond mere mood and atmospherics. The dynamism and obsessive passion of the man van Gogh are fixed and at the same time the picture achieves an astounding physiognomic fidelity. None of the van Gogh self-portraits or photographs shows him in profile – it was left to Toulouse-Lautrec to render his friend this service. The portrait is not only profound in its psychology, it also shows us the receding brow and hooked nose which were typical of the van Gogh family.

The two painters, so very different in background and temperament, probably became acquainted in February 1886, when van Gogh had just arrived in Paris from Holland and Antwerp, was living with his brother Theo (who was an art dealer), and had joined Cormon's studio. Outsider Henri scented outsider Vincent and, communicative as he was, made contact with him. No doubt he also helped ease contact between the new studio member and other Cormon cronies: we know that Toulouse-Lautrec's friends Charles Laval, Eugène Boch, François Gauzi, Louis Anquetin and Emile Bernard were van Gogh's too within a short space of time.

Cormon, a liberal-minded salon artist, kept an atelier that was a major centre of Post-Impressionism, or rather, to be precise, of that splinter-group of Post-Impressionist style known as cloisonnism, from the French "cloisonné", an enamelling procedure. Several of Cormon's pupils imitated the techniques of this craft, among them Bernard, Anquetin, van Gogh, occasionally Toulouse-Lautrec, and indeed (through Bernard's

Quadrille on a Louis XIII Chair, 1886
Pen and pencil, 50 x 32 cm
Musée Toulouse-Lautrec, Albi

LEFT:
Portrait of Vincent van Gogh, 1887
Pastel on cardboard, 54 x 45 cm
Rijksmuseum Vincent van Gogh, Amsterdam

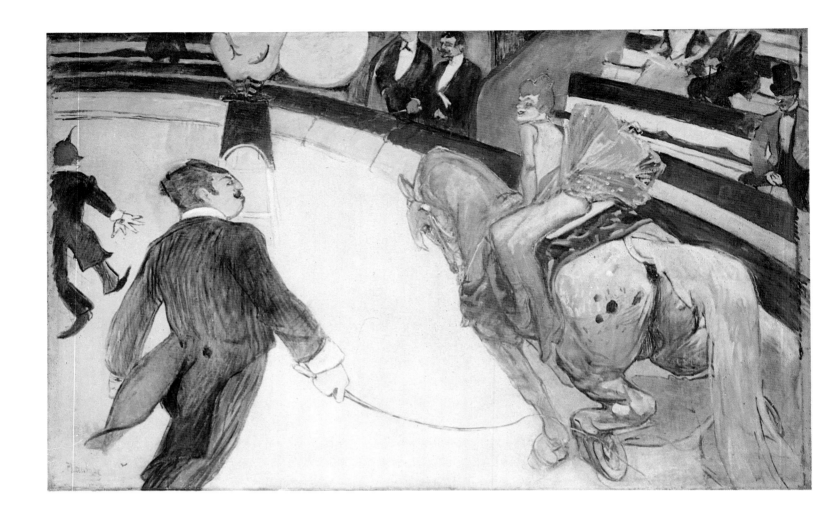

Cirque Fernando: The Equestrienne, 1888
Oil on canvas, 100.3 x 161.3 cm
Art Institute of Chicago, Chicago

"Degas encouraged me by saying the work I had done this summer was not bad. How much I would like to believe it!"

TOULOUSE-LAUTREC

offices as go-between) the outsider Paul Gauguin: the technique involved highly abstract zones of colour, often contained in dark outlines and clearly defined. In the art of enamels, or indeed in the lead framing of stained glass, outlines of this kind had self-evident technical reasons, but the cloisonnists made a virtue of the autonomous artistic value of the formal process. Emphasized contours and the stylized approach of Japanese woodcuts confirmed their sense that stylistic means of this kind had an independent significance which could simplify and intensify (even through distortion) expressive effects. Toulouse-Lautrec retained "Japanese" elements in his mature style: the absence of shadows, diagonal lines in the composition, surprisingly sectional approaches to pictures, and certain decorative arabesques.

Not long before he left for Arles, van Gogh observed Toulouse-Lautrec at work on "Rice Powder" (Stedelijk Museum, Amsterdam): the painting, which shows a woman making up at her dressing table, was done in an Impressionist style and completed in 1888, and was bought privately by Theo van Gogh. That same year Toulouse-Lautrec painted his first masterpiece, "Cirque Fernando: The Equestrienne" (p. 20). The composition and arrangement of the painting betray a strong Japanese inspiration, but nonetheless it bears the fully

individual stamp of the French artist, who – like his fellow-artists – had by now quit Cormon's studio. The motif of the circus was popular at the time: in 1879 Edgar Degas had painted his "Miss Lala at the Cirque Fernando" (National Gallery, London), which shows a trapeze artiste at a heavily foreshortened angle from below and is similarly influenced by Japanese art.

The motif of the circus rider, though, was Toulouse-Lautrec's own original idea; Georges Seurat and Pierre Bonnard were both to emulate him in due course. But none of them, Degas included, had Toulouse-Lautrec's ability to convey so suggestively the fleeting physical impression of power given by the horse along with the side-show excitement of the clowns. The painter's secret lies not in any kind of academic realism, not in Impressionist means, but in his unique approach to formal questions of colour and composition. The horse is seen at an angle, from the rear, galloping from the lower right into the heart of the

"He wears my clothes, but cut down to his own size." EDGAR DEGAS on Toulouse-Lautrec

"I prefer Lautrec." PAUL CEZANNE, asked about Degas

"A la Mie", 1891
Oil and gouache on cardboard,
53.5 x 68 cm
Museum of Fine Arts, Boston

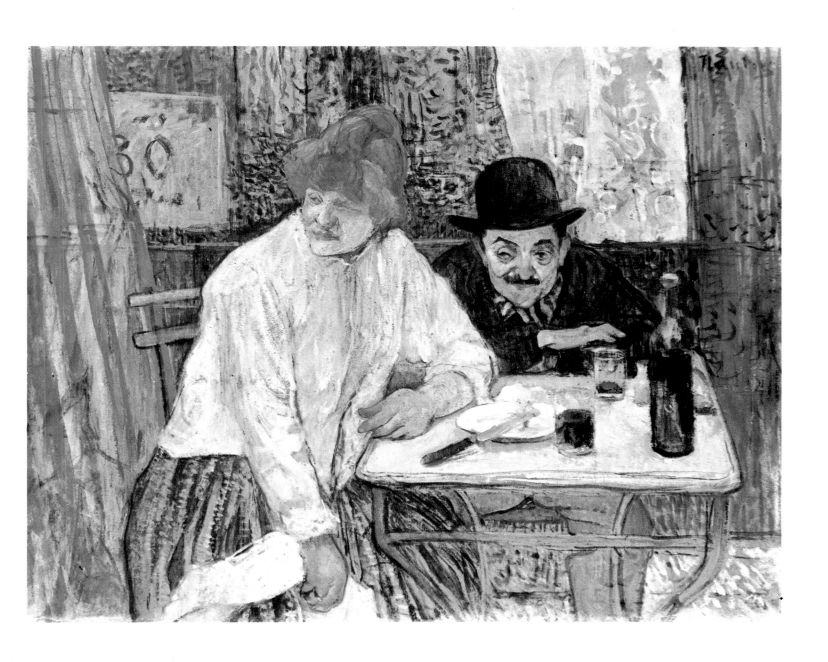

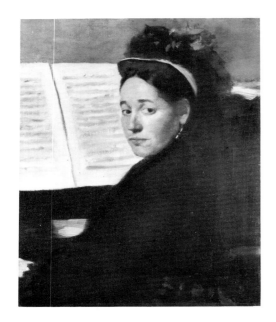

EDGAR DEGAS:
**Marie Dihau at the Piano,
ca. 1869–1872**
Oil on canvas, 39 x 42 cm
Musée d'Orsay, Paris

"Lautrec's picture, the portrait of a woman musician, is quite astounding and has moved me deeply." VINCENT VAN GOGH

**Mademoiselle Marie Dihau
Playing the Piano, 1890**
Oil on cardboard, 69 x 49 cm
Musée Toulouse-Lautrec, Albi

picture, the way ahead marked by the red ranks of seats. The diagonal dynamic which splits the picture into two sections was a favourite device with Japanese artists too. Toulouse-Lautrec retains empty space in the centre of his canvas, a startling effect for contemporaries used to compositions with a central focus. The two asymmetrical parts are linked through dynamic gestures and movements: the horse is moving forward and to the left into the open space of the circus ring, while the master of ceremonies on the left is cracking his whip across the empty space of the central foreground. This action of the ringmaster's creates a bridge to the horse and rider. The clown fooling about on the left and a second one on a platform further back, as well as the seated audience, are cut away by the edges of the painting – another "Japanese" trick. The Japanese habit of allowing the sectional view to appear dictated almost by chance had fascinated Degas and inspired him to imitation, and Toulouse-Lautrec too, in this his first work of genius, borrowed the technique.

Undoubtedly Degas was the most important influence and exemplar among the younger painter's older contemporaries. His academic teachers Bonnat and Cormon had given Toulouse-Lautrec a technical foundation, but his own stylistic beginnings were dictated by the Impressionists and those associated with them. Understandably, it was the painters who emphasized figural work who most inspired the young lover of animals and people; and Degas's subjects in particular became Toulouse-Lautrec's subjects, though the stress was often shifted. Women seen at the milliner's or at the dressing-table, in music-cafés or brothels, laundry-women and dancers – all of them met the criteria Charles Baudelaire and Emile Zola had set up for an art that would reflect modern life.

Toulouse-Lautrec was living in Montmartre in the same house where Degas had his studio, and so were the three Dihau sisters, who were in fact distant relatives. About 1870 Degas had painted a portrait of the pianist Marie Dihau, seated at the piano and turned to the viewer (above left), and in 1890 Toulouse-Lautrec followed suit with a painting of this woman playing the piano in her apartment (right). In the background to the right we can make out Degas's painting on the wall – subtle homage to Toulouse-Lautrec's idol. The portrait is in a mixed style between Impressionism and cloisonnism and, like the pastel of van Gogh, it succeeds in showing not only a spontaneous moment but also the character and essence of the subject. We see Marie Dihau amid stacked and opened scores, concentrating on her playing; the pictures on the wall, one of which Toulouse-Lautrec has used to bear his own signature, symbolize the cultured ambience of the family. By using a sparing yet rich palette, the artist has created shimmering colour effects.

The younger painter's admiration for Degas tended to be one-sided. Degas, who was in any case widely thought a misanthropist, adopted a patronizing tone towards his stunted junior. This may have been the result of a competitive instinct, though: for example, if we compare Toulouse-Lautrec's unachieved masterpiece "A la Mie" (p. 21)

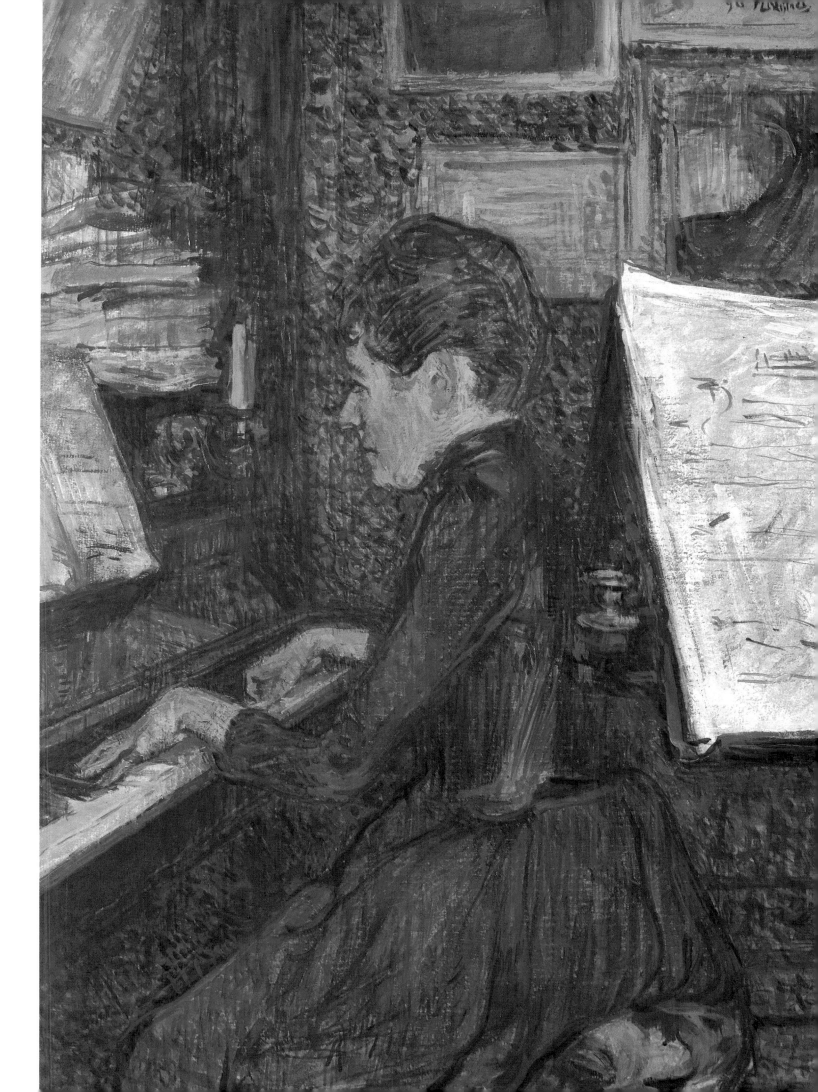

**The Morning After (Suzanne Valadon),
1889**
Indian ink and blue crayon, 49.3 x 63.2 cm
Musée Toulouse-Lautrec, Albi

"The last day or so I've had a lot of fun at
the 'Chat Noir'. We set up an orchestra
and got the people dancing. It was very
entertaining and no one went to bed till
five in the morning." TOULOUSE-LAUTREC

The Actor Henry Samary, 1889
Oil on cardboard, 75 x 52 cm
Musée d'Orsay, Paris

with Degas's "Absinth" of 1876 (Musée d'Orsay, Paris), a painting with
great thematic and atmospheric similarity, we see that beyond the
obvious resemblances there are also clear differences that lead us today
to think Toulouse-Lautrec's the finer work. Degas's is a bold painting, but
it has a somewhat formalist flavour, with its "Japanese" diagonals and its
cut-off edges. The actual subject of the picture – two people in a mood
of tired, melancholy togetherness – has been pushed aside into the
upper right-hand corner. The various areas of the painting are gently
and elegantly handled and the pastel colours have a certain reticence,
so that what is in fact a well-observed, Naturalistic slice of modern
Parisian life loses some of its edge and impact: form wins out over
content.

In Toulouse-Lautrec's picture, on the other hand, we have not only
the interior of a bar with a couple sitting at a table but also a
shrewdly-realised character scene. The happy tipsiness of the man (the
artist's friend Maurice Guibert sat for him) is countered by the bad mood
of the red-haired slut who is turning away from him. The model for this
female character, as also for "Rice Powder", was Suzanne Valadon,
mother of Maurice Utrillo and herself a perfectly good painter later on.
It is typical of Toulouse-Lautrec's incorruptible gift for observation that he
will doggedly pursue what he has once seen in a model, and has a fine
memory for the atmospherics of such a scene and will reproduce it in a
painting. What conveys to us the condition of this grouchy couple on the
skids is both the predominance of aggressive shades of red (colour used
as a signifier of meaning) and the restless, at points sketchy and raw
manner of the execution. For Toulouse-Lautrec, content needed the
aptest form. In French art, so geared to harmony and decorative values,
only certain caricatures and paintings by Honoré Daumier can
appropriately be compared; and among later artists only the early
Pablo Picasso and Käthe Kollwitz achieve a similar socio-critical bite,
partly, no doubt, through following Toulouse-Lautrec's example.

It is true that Toulouse-Lautrec does not always have this empathy
himself. The born aristocrat with monarchist views never took part in the
daily round of political life, and was far from being a republican of
Daumier's ilk. Nonetheless, in the Bohemian world of Montmartre's bars
and meeting places, free of restraint and open to lovers and outsiders
and all who left convention behind, he found his world, and himself.
Among the quaint and curious, the painter attracted less attention than
he would have done in the milieu he was born to, with people who did
not care to face truths and preferred to cling to the dream of their caste
rather than acknowledge that times had changed. In reaction to the lie
his family was living, Toulouse-Lautrec opted for a trivial, brutal,
everyday reality.

Dance clubs exercised a special fascination. At first he tried to
record the abandoned amusement of the crowd at the "Elysée
Montmartre", in a sketchy-cum-Impressionist manner; then, in the late
1880s, he came to prefer the "Moulin de la Galette", a cabaret club that
had been set up in an old windmill in the Rue Lepic and enjoyed

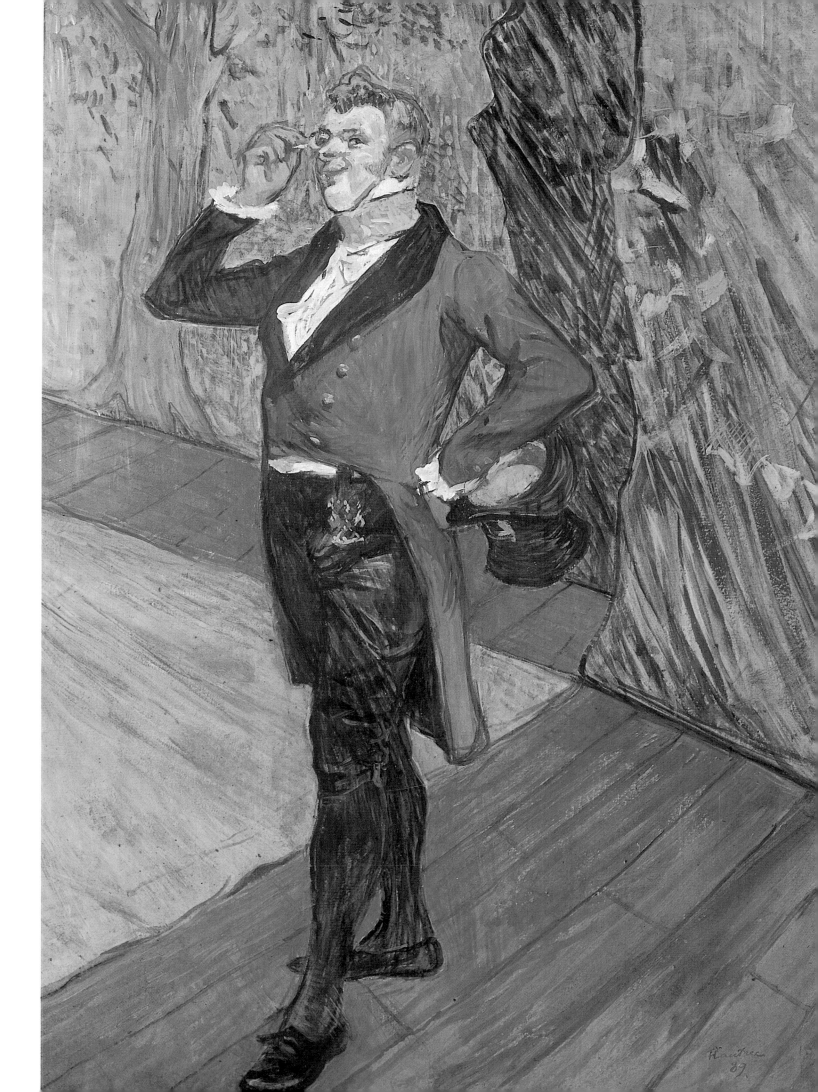

long-lived popularity. Pierre-Auguste Renoir had already painted the garden of the "Moulin" in 1876, and the work, one of his best, shows the Impressionist manner at its least stiff (Musée d'Orsay, Paris). Toulouse-Lautrec, painting in 1889 (below), gives us the interior. As in the circus painting, a diagonal (the side of the dance-floor) jags across the picture, leading the eye to the background. Women wanting to dance are lined up at the rail, and beyond them a man in a hat is leaning on his table. They are all gazing in different directions, which creates a set of imaginary horizontals that (as it were) gives a psychological dimension to the foreground, suggesting spiritual isolation, friendly camaraderie, brooding emptiness, a whole tangle of polarities. In the background people are dancing and one group is talking. The diagonal of the rail,

At the Moulin de la Galette, 1889
Oil on canvas, 88.9 x 101.3 cm
Art Institute of Chicago, Chicago

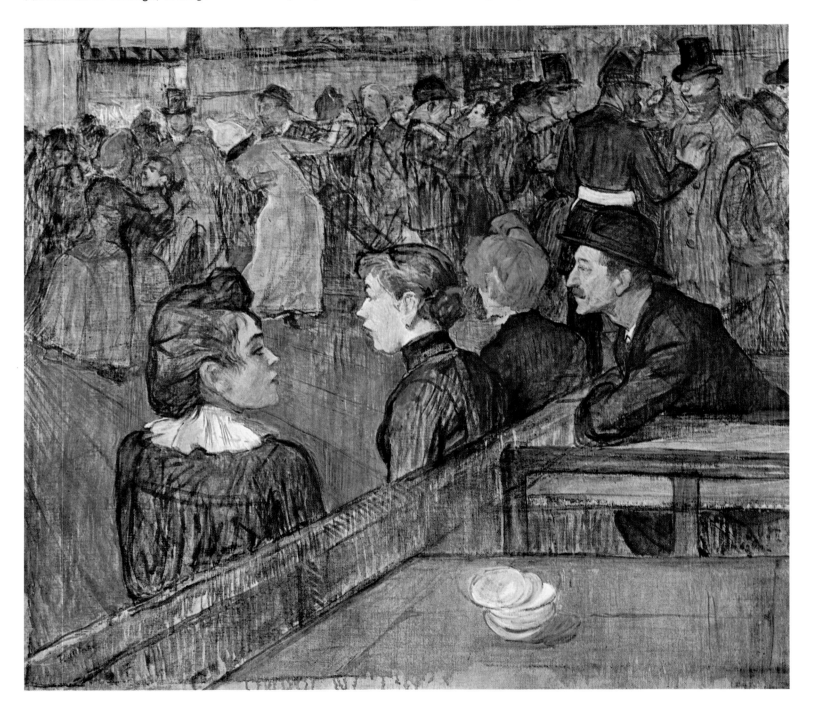

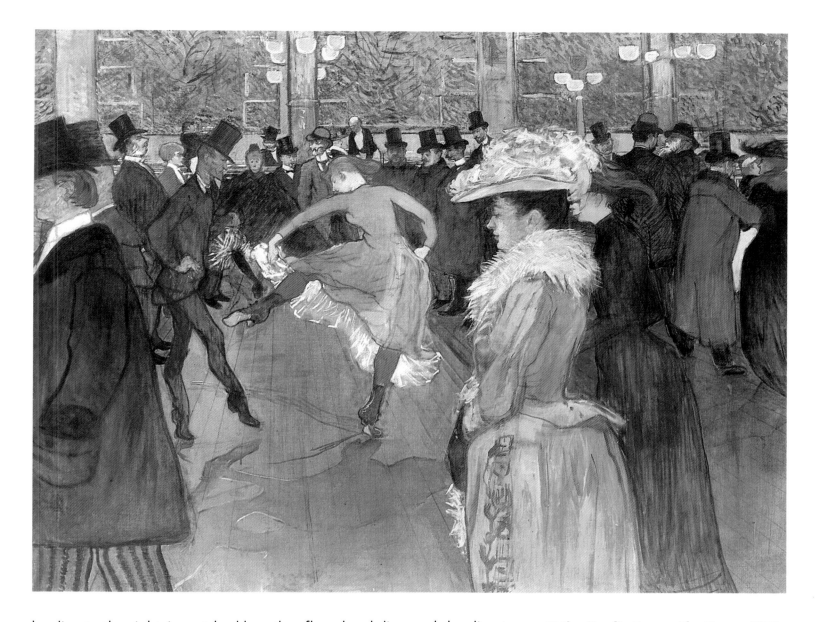

At the Moulin Rouge: The Dance, 1890
Oil on canvas, 115.5 x 150 cm
Philadelphia Museum of Art, Philadelphia

leading to the right, is matched by other floor-level diagonals leading to the left. Indeed, the whole picture takes its life from these tensions between foreground and background, right and left. The oil paint has been applied very thinly at points as if it were watercolour, and at times very sketchily or runnily, and the background in particular is no more than a shimmer of brushstrokes. In all, the painting gives a perfect impression of the atmosphere of the moment in a dance-club.

One year later, Toulouse-Lautrec did a big painting of night-life in another dance-club, one which had opened in 1889 and was soon to steal the thunder and customers of the "Moulin de la Galette", the "Moulin Rouge". The painting was "At the Moulin Rouge: The Dance" (above) and it is a far more complex and mature composition than the previous year's work. Spatial depth is largely suggested by the positioning of figures. At centre left, surrounded by onlookers, La Goulue (the Glutton) and Valentin-le-Désossé (Valentin the Snakeman) are dancing, two cabaret artistes who, like the "Moulin Rouge" itself, were to enter art history through Toulouse-Lautrec.

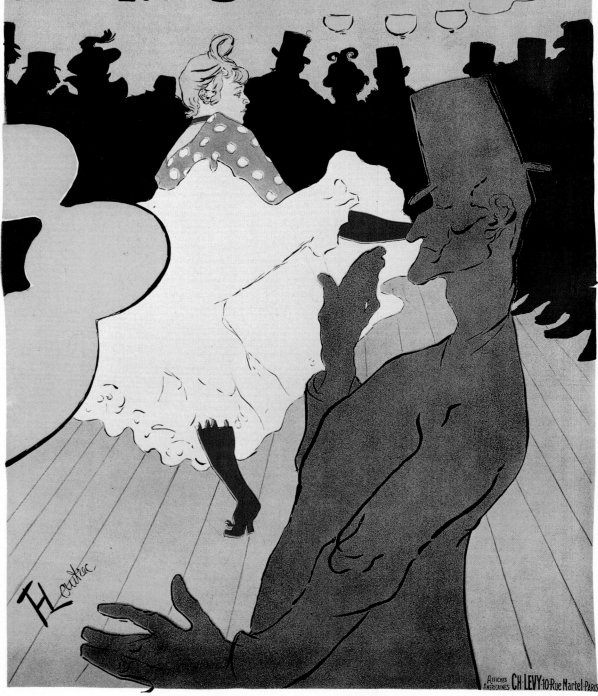

A Kaleidoscope of Stars

In the great hall of the "Moulin Rouge", in the light of yellow lamps and surrounded by the black silhouettes of customers hungry for fun, La Goulue and Valentin-le-Désossé are dancing (left). They are the star attractions of the cabaret, opened just two years before, and both are at the peaks of their careers. In the foreground we see the half-figure of Valentin in a shimmering grey-green side-view silhouette, the effect of which is at once both muted and heightened by the flat colouring and a stylized, curved use of the line. His shadowy, sketchy figure partly conceals his partner, swirling about behind him – the only person in the picture who is portrayed as anything other than a silhouette. She too, though, is artistically simplified, and is very cleverly fitted into the painter's composition, not fully visible to us but instead cut off by Valentin at the right and with her fluttering white dessous hidden at left by a set of lamps. The spatial depth of the hall is conveyed by two main perspective devices: the lines of the floorboards lead to the rear, and the figures differ in size. Red and black lettering above it all tells us what is being advertised: the club where La Goulue performs and where there is a ball every evening.

When the poster went up in the streets of Paris, Toulouse-Lautrec became a celebrity overnight. In his laconic way, he wrote to his mother in October 1891: "My poster was pasted up on the walls of Paris today, and I shall soon be doing a new one." Toulouse-Lautrec's entry into graphic printing was electrifying. Previously he had provided material for magazine illustrations, but the printing was mechanical so that the result was not original graphic art; now, at the age of twenty-seven, and after a relatively long period of hesitation at the outset of what was to be his last decade of life, he plunged into work in a medium that was to prove his natural artistic element. Apart from a few ventures into etching, which were far from satisfying him, Toulouse-Lautrec was from now on to consider monochrome or coloured lithographs his most vital expressive medium. The catalogue of his work lists some 350 lithographs in all, about thirty of them posters; not all of these are works of the first rate, but a dozen are among the very best that utilitarian art has produced.

When Toulouse-Lautrec began to produce lithographs in 1891,

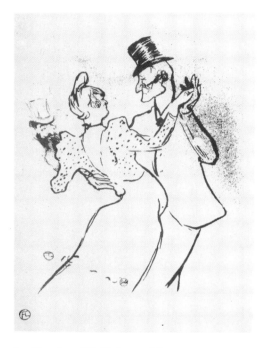

La Goulue Waltzing with Valentin-le-Désossé, 1894
Monochrome lithograph, 31.4 x 25.7 cm
Museum of Modern Art, New York

LEFT:
Moulin Rouge – La Goulue, 1891
Coloured lithograph (poster), 191 x 117 cm
Civica Raccolta di Stampe Bertarelli, Milan

29

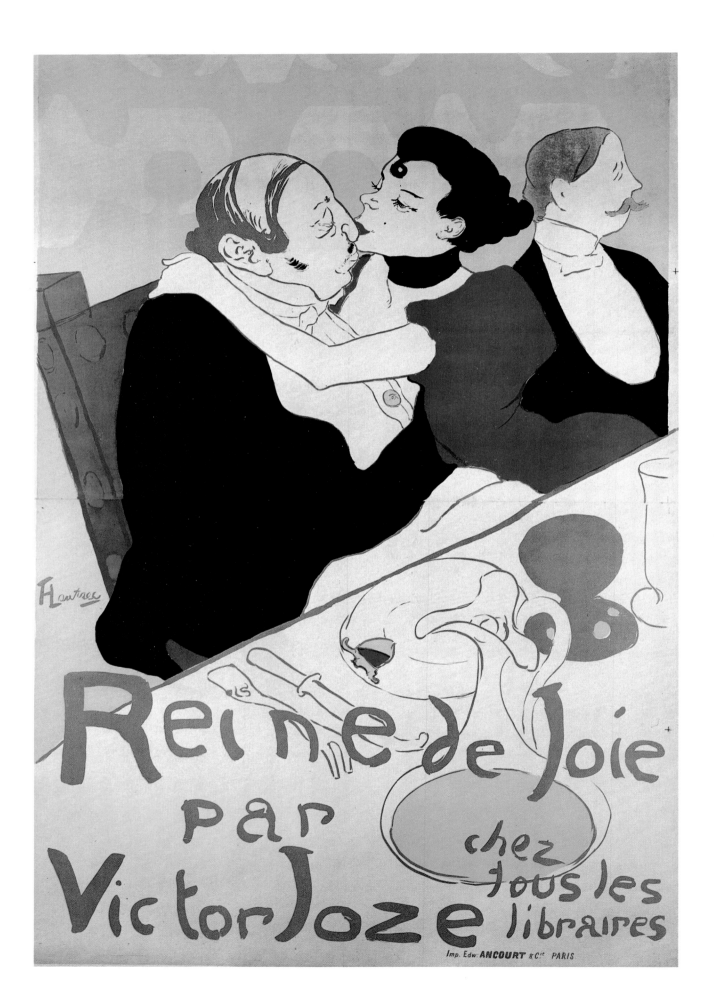

lithography had a century of history behind it: Alois Senefelder had invented the technique of printing from stone in Munich in 1796. Senefelder had found that if one drew on porous limestone with fatty chalk, moistened the areas that had not been drawn on, and covered the whole with fatty coloured printing ink, the moistened parts do not absorb the ink and in printing on paper only the chalked parts take. In the course of time the process had become more sophisticated through the use of chemicals. At the start of the 19th century, lithographic printers started up business in Paris, initially concentrating on the reproduction of written texts or musical scores; by degrees, artists discovered the technical and material potential of lithography.

By 1820 the first lithographic masterpieces had been created, by Théodore Géricault, Richard Parkes Bonington, Francisco de Goya and Delacroix, among others. There were also specialists such as the Frenchman Nicolas-Toissaint Charlet and his pupil Denis-Auguste-Marie Raffet, who were less well-known than these painters. Before Toulouse-Lautrec, the most significant of French lithographic artists were Paul Gavarni and Daumier. Both of them did most of their work for illustrated magazines – editors had been quick to perceive the uses of lithography for illustrative purposes. This kind of work generally consisted of commentary on current affairs, whether in a more neutral, realistic manner or in exaggerated, caricaturist vein: both Garvani and (above all) Daumier have rightly reaped praise for the high artistic quality of their work in caricatures, which they employed to plead the cause of a more just society.

By Toulouse-Lautrec's day, other methods, cheaper though not necessarily better in quality, were coming to replace the original methods of stone-printing; and photograpy also looked like a promising means of illustration. This had the effect of making Toulouse-Lautrec independent of illustrative journalism in a way that had not been true of Daumier. He was free to make lithographic posters his own special province, along with lithographic work expressing his own concerns; the posters were his starting-point.

Studies and sketches which have been preserved show us clearly how carefully the artist prepared the "Moulin Rouge" poster. He used paintings, watercolour and pastel drawings, sketches, and even lithographs (p. 29) to vary his theme of dancing at the "Moulin Rouge" and of La Goulue and Valentin. After the sensational success of this poster, the artist did further coloured prints of the "Moulin Rouge", such as his two masterpieces of 1892, "'La Goulue' and her Sister at the 'Moulin Rouge'" and "The Englishman at the 'Moulin Rouge'".

In the first "Moulin Rouge" poster, Toulouse-Lautrec again used the Japanese and cloisonnist approaches he had first used in 1888 in the circus picture: heavily simplified figurative zones, an unusual composition based on cut-offs at the picture edges, silhouetted figures on a bright ground, and linear contours so that even at a distance the poster is effective. Extreme reduction and stylized presentation of this order – a limited conjunction of lines, spaces, colours and lettering – is

"Reine de Joie", 1892
Study for the poster
Charcoal on canvas, 152 x 105 cm
Musée Toulouse-Lautrec, Albi

LEFT:
"Reine de Joie", 1892
Coloured lithograph (poster),
136.5 x 93.3 cm
Musée Toulouse-Lautrec, Albi

PAGE 32:
"Ambassadeurs": Aristide Bruant, 1892
Study for the poster
Gouache on cardboard, 140.5 x 95 cm
Stavros Niarchos Collection, Paris

PAGE 33:
"Ambassadeurs": Aristide Bruant, 1892
Coloured lithograph (poster), 150 x 100 cm
Private Collection

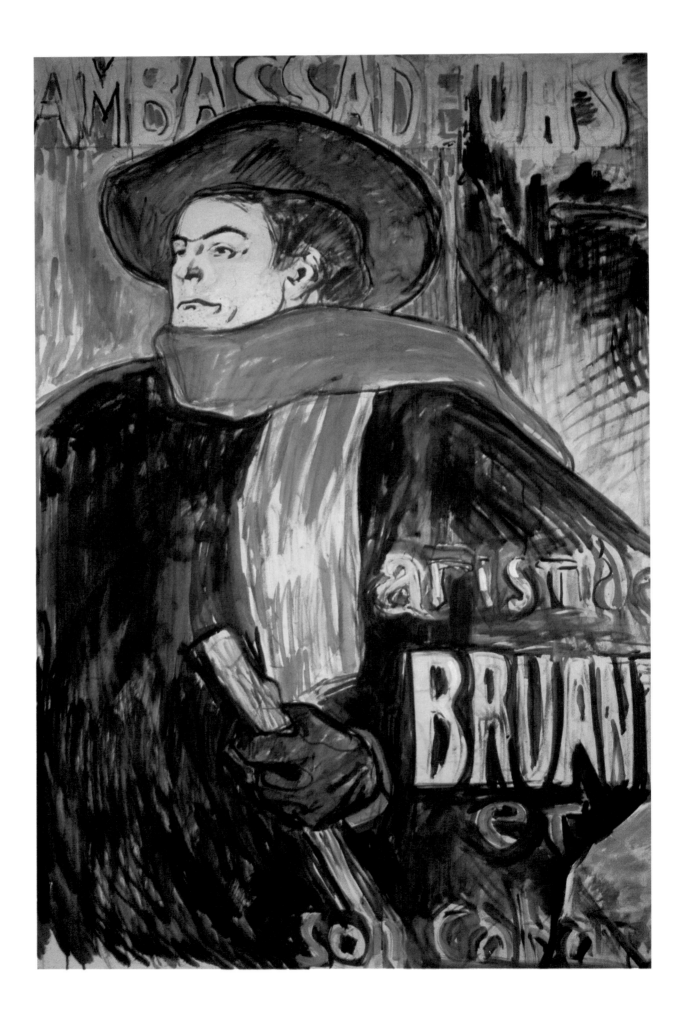

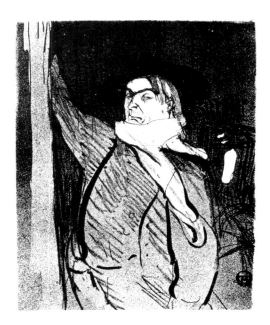

Aristide Bruant, 1893
Monochrome lithograph, 26.8 x 21.5 cm
Musée Toulouse-Lautrec, Albi

"Divan Japonais", ca. 1892/93
Coloured lithograph (poster), 80.8 x 60.8 cm
Private Collection

characteristic of his poster work and points up the contrast with his other lithographic work: the posters are the end result of a process of crystallizing that has gone through numerous stages and are no longer intended to have the vitality of a fresh sketch or a painting rifted with intuition. They have been done for a different purpose and are distilled versions of something concrete which has been seen and is a symbol of the thing advertised.

The "Moulin Rouge" poster must be the most famous poster in art history, and rightly so. Toulouse-Lautrec was hard put to reach once again the standard he had set himself, and in subsequent posters he came close a couple of times but never quite brought it off. About a dozen of the thirty posters he did are of comparable quality. If we want to see why his "Moulin Rouge" poster aroused such excitement, we have only to compare it with the poster for the same club which Jules Chéret, acknowledged king of this particular kind of utilitarian art in Paris during the 1870s and 1880s, produced two years earlier: it shows a baroquely crowded and pompous confusion of costumed dancing girls riding donkeys (see p. 94, lower right). Toulouse-Lautrec valued Chéret highly and Chéret valued him. But all Toulouse-Lautrec could do was look for a completely new and original solution, and in finding one he far surpassed the earlier poster, and created a poster style which was quickly imitated and to this day remains influential.

In 1891 Pierre Bonnard made a poster for "France-Champagne" (there is no alternative but to call it kitsch) which some art historians have wrongly thought to have been an inspiration for Toulouse-Lautrec's "Moulin Rouge" poster; he then – following Toulouse-Lautrec's success – tried his hand the next year at another "Moulin Rouge" poster, but it was never completed. Bonnard, like Edouard Vuillard (who similarly was a member of the "Nabis" or prophets, a group of artists), profited from Toulouse-Lautrec's example in the posters and lithographs, as did the Norwegian Munch as well.

In 1892 more posters followed. Together with Bonnard, Toulouse-Lautrec undertook the advertising for Victor Joze's novel "Reine de Joie", which had just been published. Bonnard designed the book-jacket, and it was relatively weak; Toulouse-Lautrec did the poster, his second major work in the genre (p. 30). We see a coquettish woman at a dinner table, kissing a portly and ugly but plainly well-to-do bald man on the nose. Once again, as in his first poster, we find Toulouse-Lautrec applying a touch of "Japanese cloisonnism" in his arrangement of areas and contour lines and highlighting colour.

In the case of the lettering, it is important to distinguish between the script the artist deliberately integrated into his posters and other graphic work (i.e. script he had done himself) and other lettering that was overprinted later at the request of the advertiser and without consulting the artist. From an artistic point of view, only the lettering Toulouse-Lautrec himself designed is of interest. It may not always strike us now as being equal in quality to the picture, and "Reine de Joie" is a

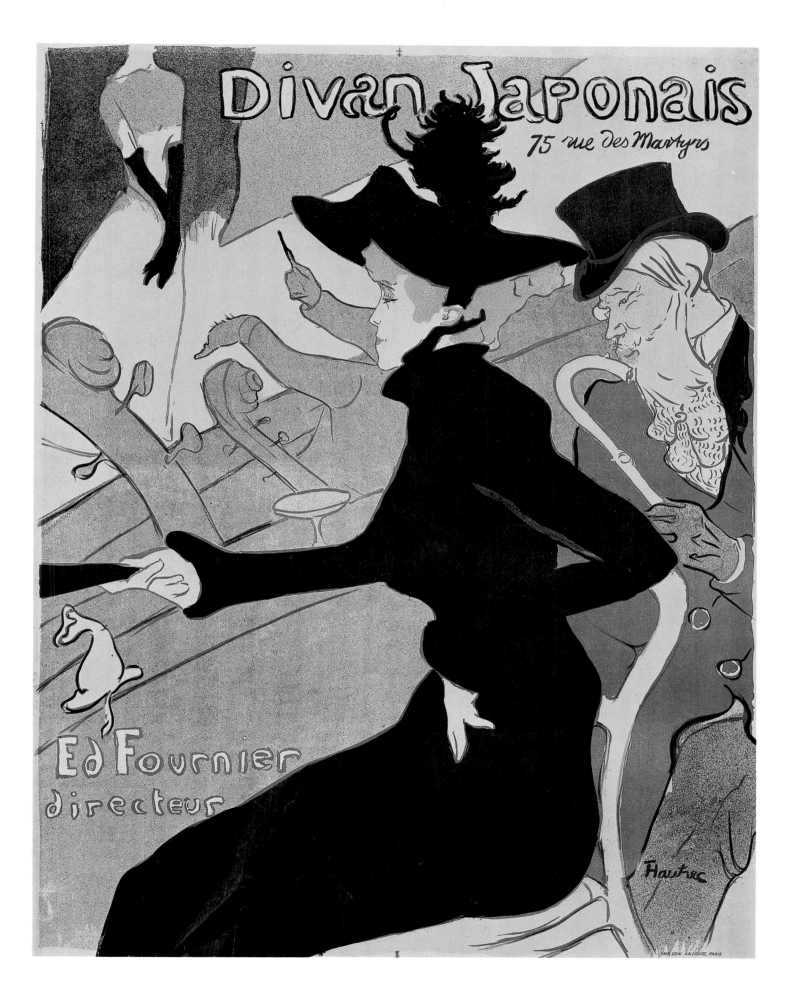

case in point, with its uneven characters, now big and now small, looking in their shakiness as if a child had written them. We can guess what was in the artist's mind when he opted to draw the letters in this way: he was aiming to integrate lettering and image into a single unified manner. But he was only rarely able to achieve this aim – best of all in the "Moulin Rouge" poster.

In the same year (1892) there followed the poster advertising the chanson singer Aristide Bruant (p. 33). It represents another attempt to give life to the genre by using idiosyncratic lettering; but what is far more interesting is the pictorial effect created by spatial reduction and the use of only the three prime colours red, yellow and blue. The result is highly evocative; and a preliminary study (p. 32) has an even livelier effect than the poster, thanks to its relaxed brushwork, and gives us an illuminating glimpse of the artist's working methods.

Toulouse-Lautrec had met Bruant some years before. Bruant had a cabaret club on Montmartre, "Le Mirliton", where he would abuse his audiences night after night, and get a great reception. But what particularly attracted both the working class and the artists and intellectuals were his chansons about life in working-class suburbs (a kind of early "chanson réaliste"). He sang in a razor-sharp voice, as recordings made around 1910 prove, and wore costumes of his own devising: atop black velvet suit and high boots, for instance, he would wear a black cape and scarlet scarf, and a broad-brimmed black hat. He often leapt up on a table and went on singing and scolding from there. He liked to affect a cane, to provide emphatic punctuation for his message.

Toulouse-Lautrec had a fine sense of artistic and human originality and was one of Bruant's early admirers. Apparently he was already entertaining fellow-students at Cormon's studio by singing Bruant's popular songs; and in the 1880s he painted a number of pictures for Bruant's cabaret, pictures that referred to the goings-on in the club or to the proprietor's hard-hitting chansons. With other Montmartre artists, such as Théophile Steinlen and Adolphe Willette, he also provided illustrations for Bruant's in-house newsletter, also called "Le Mirliton". When Bruant commissioned the first of four posters from Toulouse-Lautrec in 1892, the chansonnier had long made his name as a star and at times appeared at other, bigger venues; and the first poster was meant for one such guest appearance, at the "Ambassadeurs". The artist has neatly allowed the hat Bruant is wearing to cover part of the lettering of "Ambassadeurs", a trick that remains popular to this day. When Bruant gave a guest performance at the "Eldorado" cabaret, Toulouse-Lautrec simply altered the name of the club and printed the image the other way round. But the first version is without doubt the more effective. There were two further posters of Bruant in 1893 and 1894, one showing him at an angle and one from behind, one a half-figure with cape, hat and red scarf, the other a full-length in suit and boots standing on cobblestones.

Yvette Guilbert, 1894
Charcoal, coloured ink, 186 x 93 cm
Musée Toulouse-Lautrec, Albi

LEFT:
Yvette Guilbert Taking a Curtain Call, 1894
Gouache on cardboard, 48 x 28 cm
Musée Toulouse-Lautrec, Albi

PAGE 38:
Jane Avril dancing, 1893
Study for the poster for the "Jardin de Paris"
Gouache on cardboard, 99 x 71 cm
Stavros Niarchos Collection, Paris

PAGE 39:
Jane Avril at the "Jardin de Paris", 1893
Coloured lithograph (poster), 130 x 95 cm
Private Collecton

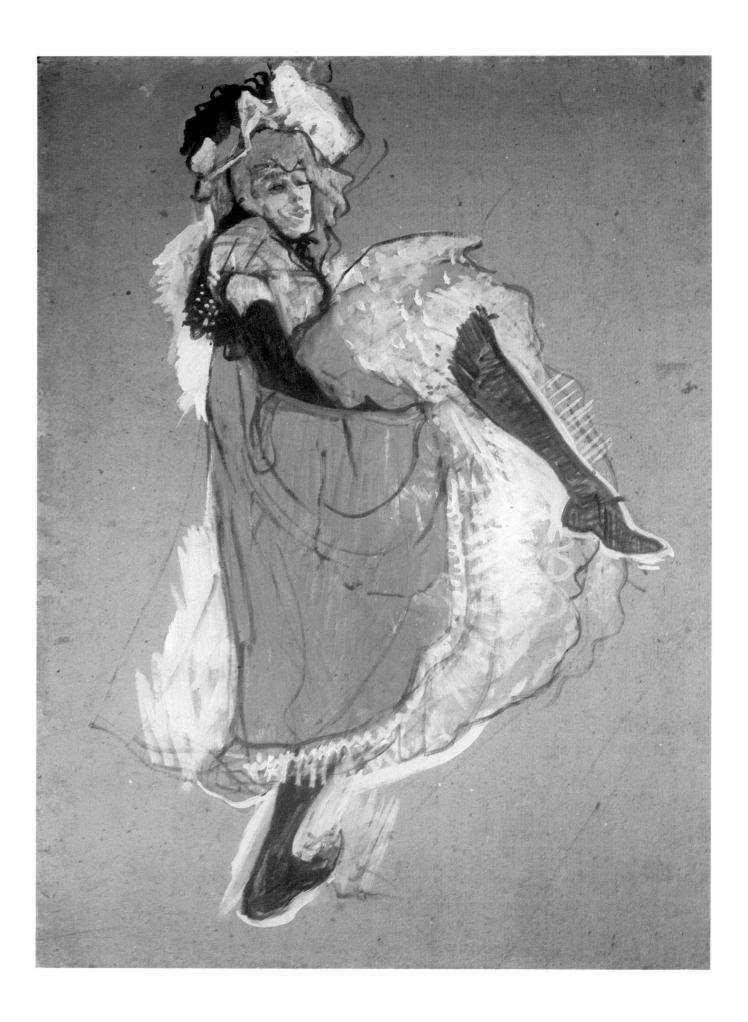

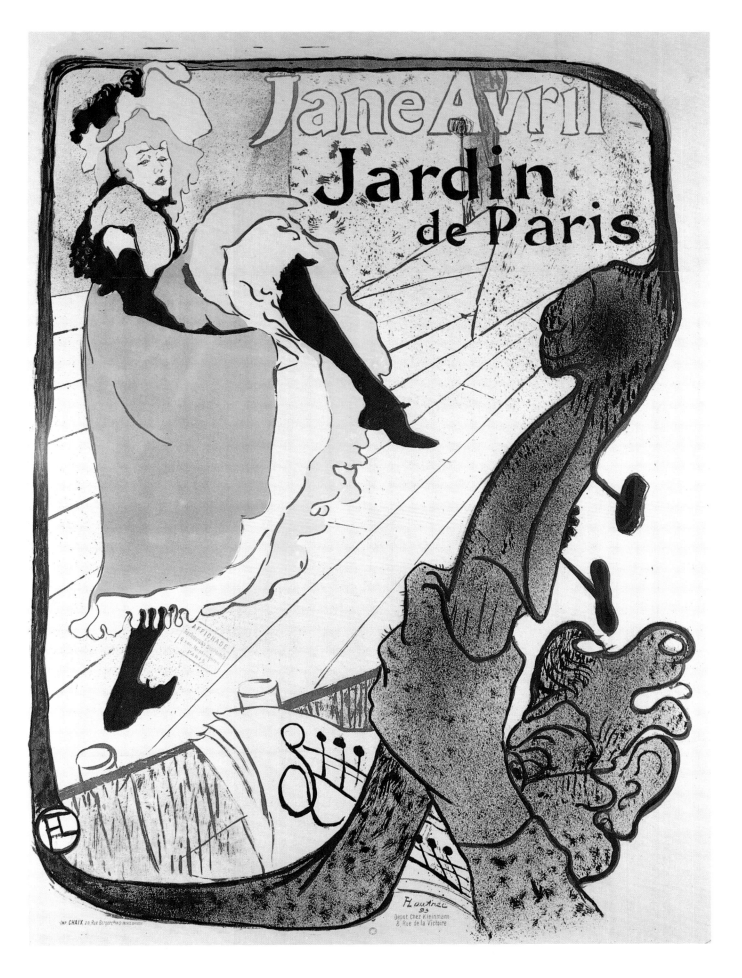

Yvette Guilbert, 1893
Monochrome lithograph, 25.3 x 22.3 cm
Private Collection

"But for heaven's sake don't make me so terribly ugly! Not quite so much…! A lot of people let out horrified screams when I showed them the coloured sketch… Not everybody sees the artistic angle only… and a lady!!! A thousand thanks from your very appreciative Yvette." YVETTE GUILBERT

Misia Natanson: "Tell me, Lautrec, why do you always make your women look so ugly?"
Toulouse-Lautrec: "Because they are ugly!"

"Confetti", 1894
Coloured lithograph (poster), 54.5 x 39 cm
Private Collection

Yvette Guilbert, who performed in a variety of music cafés and cabaret clubs and at times sang chansons by Bruant, was another celebrated star. She too was able to make recordings, which show that she was also of the school of chanson realism which in our own time we are familiar with from the singing of Jacques Brel, Leo Ferré, Georges Brassens or Edith Piaf. As with Bruant, whose dress style became a trademark, Toulouse-Lautrec stylized Yvette Guilbert's appearance, rendering her in "silhouette" (his own expression). In his 1892 poster advertising the "Divan Japonais" (p. 35), the main subject of which is the dancer Jane Avril (seated in the foreground), the artist paid his first homage to his much-admired Yvette Guilbert, who appears in the upper left, singing a chanson on the club stage. Her head has been cut away by the top edge of the picture, but she is recognisable from her slenderness and her long black gloves, which Toulouse-Lautrec later made famous in the lithographs he devoted to the artiste. In her memoirs, the singer noted that this stylized image was if anything a product of chance and necessity: "At the start I was very poor, and since black gloves don't cost much I opted for black gloves. But whenever I could I wore them with bright dresses, and pulled so high up that they emphasized the slenderness of my arms and gave elegance to my shoulders and my long thin neck."

The relationship between Guilbert and Toulouse-Lautrec is typical of the repellent impression the artist made on first acquaintance, both physically and artistically. When she first met him, the diva was shocked by the man's stunted stature. Only one feature she found compelling – his dark brown eyes, which other contemporaries also noted: "They are beautiful, large, and gleaming with warmth and spirit. I can't take my eyes off them, and Lautrec, who well knows his only strong point, hastily takes off his pince-nez to give me a better look. As he does so I notice his droll dwarf's hand, a broad and angular hand at the end of a singular little marionette's arm… He wanted to fix a day the following week to make sketches, portraits and silhouettes of me… Three weeks later he turned up with all his little drawing things and said: 'I know I'm not expected, but I'm doing an exhibition of drawings, and I can't not have Yvette Guilbert, can I?' So I sat for him."

Toulouse-Lautrec made a great many drawings, gouaches and lithographs of Yvette Guilbert. There were plans for a poster, but they fell through, probably because the sitter, accustomed to the prettifiying approach of other portrait artists, was too hesitant over giving Toulouse-Lautrec a definite commission. A number of letters the singer wrote in 1894 clearly tell us how shocked she was by the artist's way of seeing and depicting her. But in the end she became convinced of his value. Now, of course, we know that it was only because of Toulouse-Lautrec's works that Guilbert achieved any kind of immortality, and she did so because he reproduced what was essential in her and did without the decorative adornments which other Guilbert portraitists and poster-makers added.

He made two series of black-and-white lithographs devoted

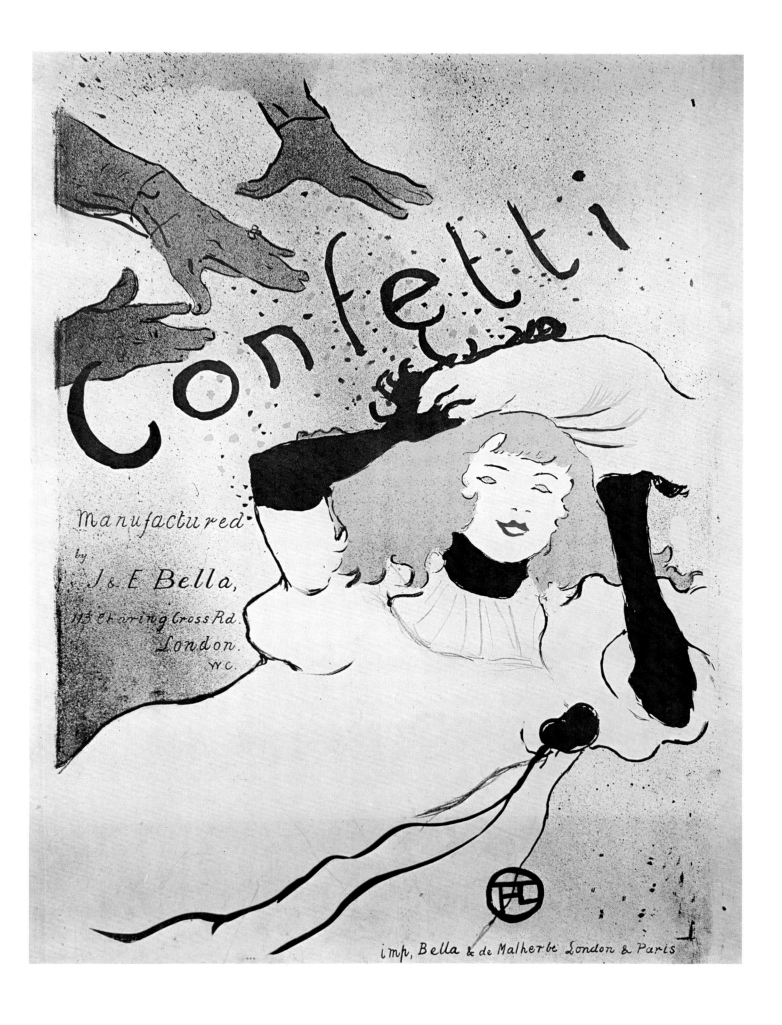

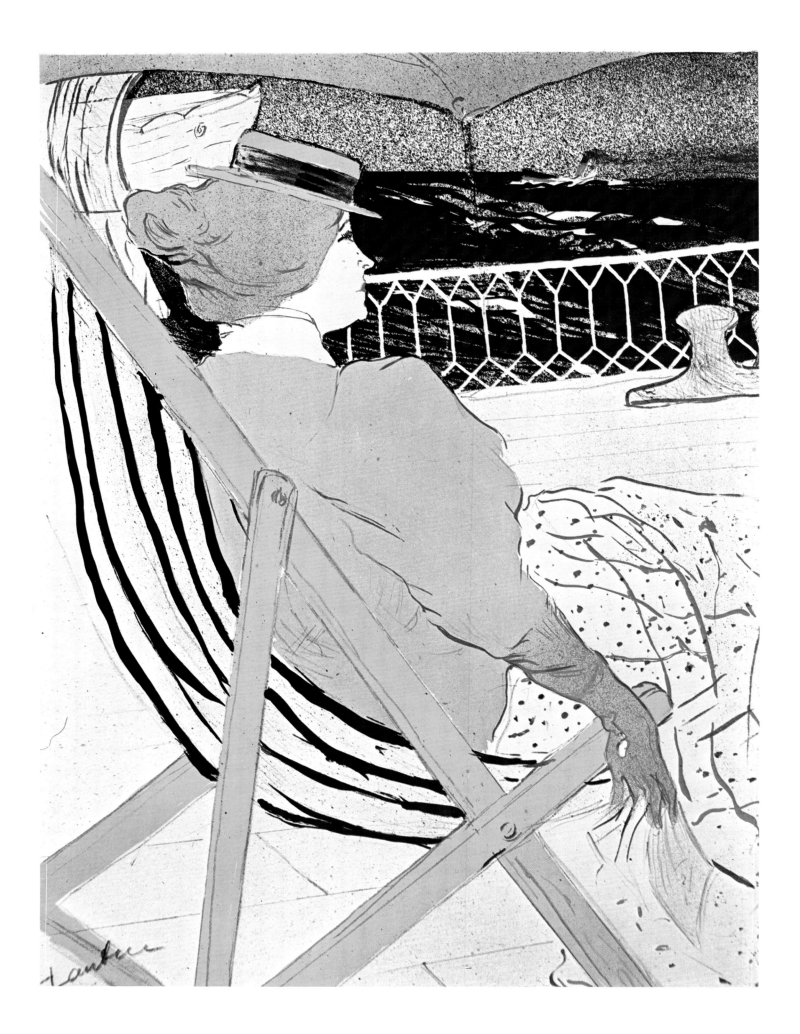

entirely to Yvette Guilbert. The first album was published in Paris in 1894. It includes a commentary by the art critic Gustave Geffroy which unfortunately often covers the lithographs. There are, however, copies without the printed text. The second album appeared in London in 1898 and is therefore known as the English Series. In it, Toulouse-Lautrec preferred close-ups of the artiste, mostly head-and-shoulders or half-figure studies, whereas the first album had focused on the overall phenomenon of Guilbert, the "silhouette". "Let us go and define Yvette," Toulouse-Lautrec once remarked as he set out to visit the singer. His definitions are vivid and highly original, not solely because of his simplified and epigrammatic presentation but also because of a quality in the sensitively-observed moment, that moment (for instance) when she spread her gloved fingers while singing (p. 37) or took her bow afterwards (p. 36). Not even the recordings or films that preserve Guilbert for us convey so memorable an impression of the singer as Toulouse-Lautrec's genius manages in these pictures.

He immortalized other stars on his posters too, most of them women, such as Jane Avril, who performed at the "Moulin Rouge" and elsewhere. The poster Toulouse-Lautrec designed for the "Jardin de Paris" in 1893 (p. 39) shows the dancer doing the cancan on the club stage; here once again, the flatly stylized figure contrasts with the spontaneous ease of a preliminary study (p. 38). An orchestra musician's double bass provides the picture with an asymmetrical, rounded frame which anticipates art nouveau decoration; Toulouse-Lautrec then got to know art nouveau mannerisms in England and Belgium, and the influence is particulary apparent in the second Jane Avril poster (right), done in 1899, with its ornamental use of space and of course the spiral pattern of the snake curled around the dancer's body.

In 1895, Toulouse-Lautrec did posters of the Irish singer May Belfort and the American dancer May Milton. He also pictured another American dancer, Loie Fuller, swirling the white swathes of her costume through the air; this picture was made available in delicately varied coloured lithographs sprayed with gold dust. He preserved the image of an unknown fellow-traveller he had fallen in love with on board a ship from Le Havre via Bordeaux and Portugal to Africa in his coloured lithograph "The passenger in Cabin 54" (left). Later, with lettering added, she was to serve as the poster for an exhibition. But we can easily see that this picture, so complex in its composition, was not originally intended to be a poster: it has greater immediacy, atmosphere, and intimacy, and draws its power from extremely personal and possibly desperate experience. Toulouse-Lautrec was making himself an image of what remained unattainable for him: a beautiful and sophisticated woman who personified the real life that he was largely excluded from.

Usually a lengthy series of preliminary studies preceded Toulouse-Lautrec's lithographs. Once he was attracted by a particular subject, stages on the way to the final litho might include a spontaneous sketch, a more thorough drawing, a watercolour study, or a study in tempera or oil (usually on cardboard), through to the picture proper,

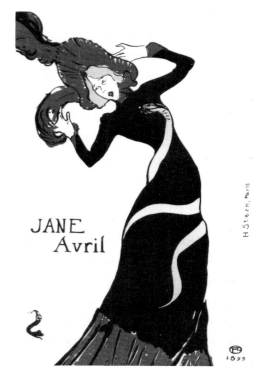

Jane Avril, 1899
Coloured lithograph (poster), 91 x 63.5 cm
Private Collection

"Without a doubt I owed him the fame I enjoyed from that very first moment his poster of me appeared." JANE AVRIL

The Passenger in Cabin 54, 1896
Coloured lithograph, 60 x 40 cm
Private Collection

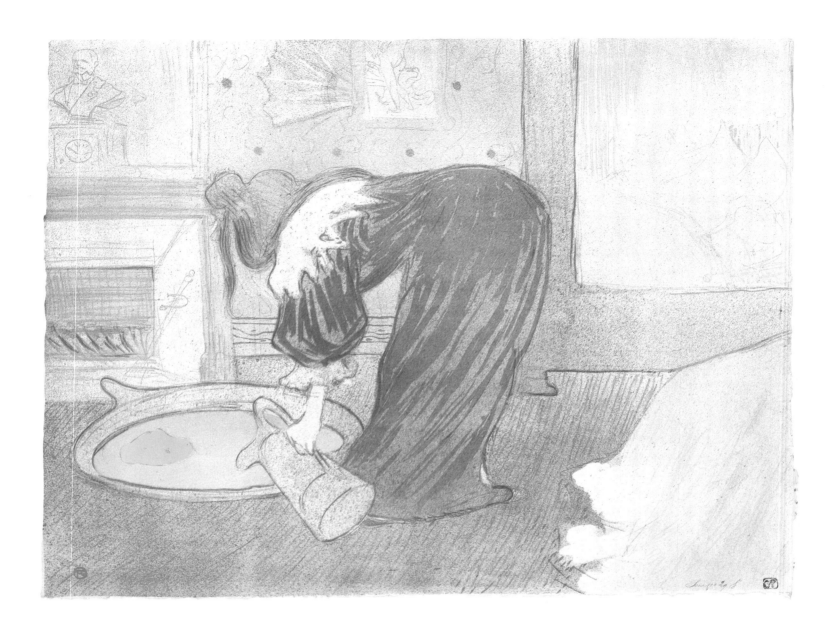

Femme au Tub, 1896
Coloured lithograph from the "Elles" album,
40 x 52.5 cm
Private Collection

which at times might be painted on canvas. On the other hand, it sometimes happened that Toulouse-Lautrec, once at the printroom, would rely on his excellent visual memory and draw straight on to the stone without any preliminaries. Perhaps his greatest strength was his rapid and unerring stroke – in the very moment of creation it both abstracted the simple essentials and clarified the subject. In the Parisian printrooms of Chaix, Verneau, and especially Ancourt and Stern, Toulouse-Lautrec was a familiar and welcome client through the 1890s. He tried out various coloured inks on papers of different colours, experimented with technical procedures, and had trial copies and then the whole editions of his lithographs printed.

As well as posters, a large proportion of Toulouse-Lautrec's black-and-white lithographs were devoted to the theatre and to stars. He was a great fan of comedies and operettas and would often go to see the same show repeatedly. At times he went to preposterous lengths,

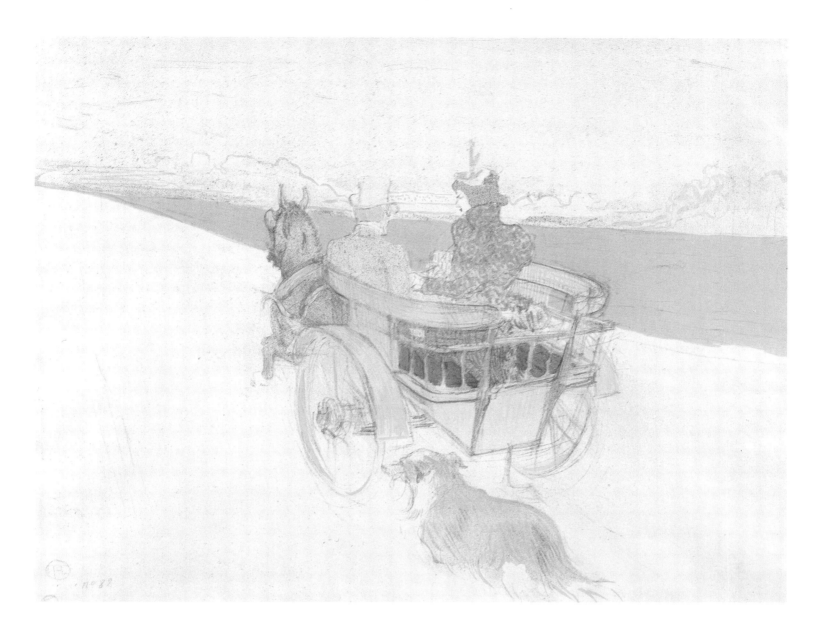

Country Outing, 1897
Coloured lithograph, 40.5 x 52 cm
Private Collection

as when he went to see the operetta "Chilpéric" some twenty times, much to the agony of those who had to accompany him, apparently because he was infatuated with Marcelle Lender's low-cut dress. Marcelle Lender was the star of this Merovingian show, and Toulouse-Lautrec recorded her snapshot-style in various scenes from the operetta in a number of lithographs. He also painted a large canvas (Whitney Collection, New York) which shows Lender in mediaeval costume dancing the bolero. In format and execution the picture constitutes an exception in the artist's œuvre. Quite possibly the huge painting was a preliminary for a coloured lithograph in a comparatively small format, a lithograph which is among his finest and today fetches a very high price: the half-length portrait of Lender which was done in 1895 and first published in the German art magazine "Pan". Julius Meier-Graefe, the editor responsible for printing, lost his job as a result.

Other stage stars of the time besides Lender appear on Toulouse-Lautrec's lithographs, either acting in scenes or portrayed

half-length in pictures that may in part have been done from photographs and are thus a species of superior fan-pics. In the artist's day, these pictures were bought on account of the stars shown, as is shown, for example, by the fact that the two Guilbert albums were signed not only by the artist but also by the singer. No one has ever captured theatrical scenes as well as Toulouse-Lautrec. His theatre lithographs may well be the best way of demonstrating his witty, feeling and epigrammatic art; formally as well as in subject matter, they owe a good deal to Japanese woodcuts of theatre people. No doubt his passion for the theatre can be explained by his romantic southern French tendency towards the dramatic, but equally the world of the theatre provided him with a substitute world. Like some voyeur, he drank down the scenes he saw on stage, just as in real life he drew sustenance from the scenes he experienced.

In 1896 Toulouse-Lautrec's album "Elles" was published in Paris by Pellet. It consists of coloured lithographs showing the everyday life of prostitutes in a brothel (p. 44). This series was revolutionary not only in its thematic material but particularly in its extremely sensitive and subtle use of the lithographie medium. Unlike in his strongly-coloured and contrastive posters, which were designed to catch the eye, Toulouse-Lautrec opted for delicate intermediate tones of colour which he combined with great originality. The gradations of light and dark and the structuring of planes are amplified by hatching and by areas consisting of countless little blots and blobs. The "Elles" album constitutes a landmark in the history of coloured lithography. Fellow-artists, the "Nabis" and Munch in particular, quickly followed suit with coloured lithographs of their own which are likewise of great importance.

The last coloured lithograph of major significance that was done separtely from poster work was "Elsa, called 'La Viennoise'" (right). Thematically it is related to the "Elles" series, but in the finesse of its tonal nuances it surpasses all Toulouse-Lautrec's previous work in multi-coloured printing. The hatching clusters round the figure like iron filings round a magnet; cloudy zones of blue and chestnut brown create a tender, flowing ambience. The wit of the picture lies in the fact that Toulouse-Lautrec is portraying a prostitute fully clad – we cannot even guess at her body beneath this clothing. All we are offered is her face, fashionably made up and rather on the vacuous side.

Elsa, called "La Viennoise", 1897
Coloured lithograph, 58 x 40.5 cm
Musée Toulouse-Lautrec, Albi

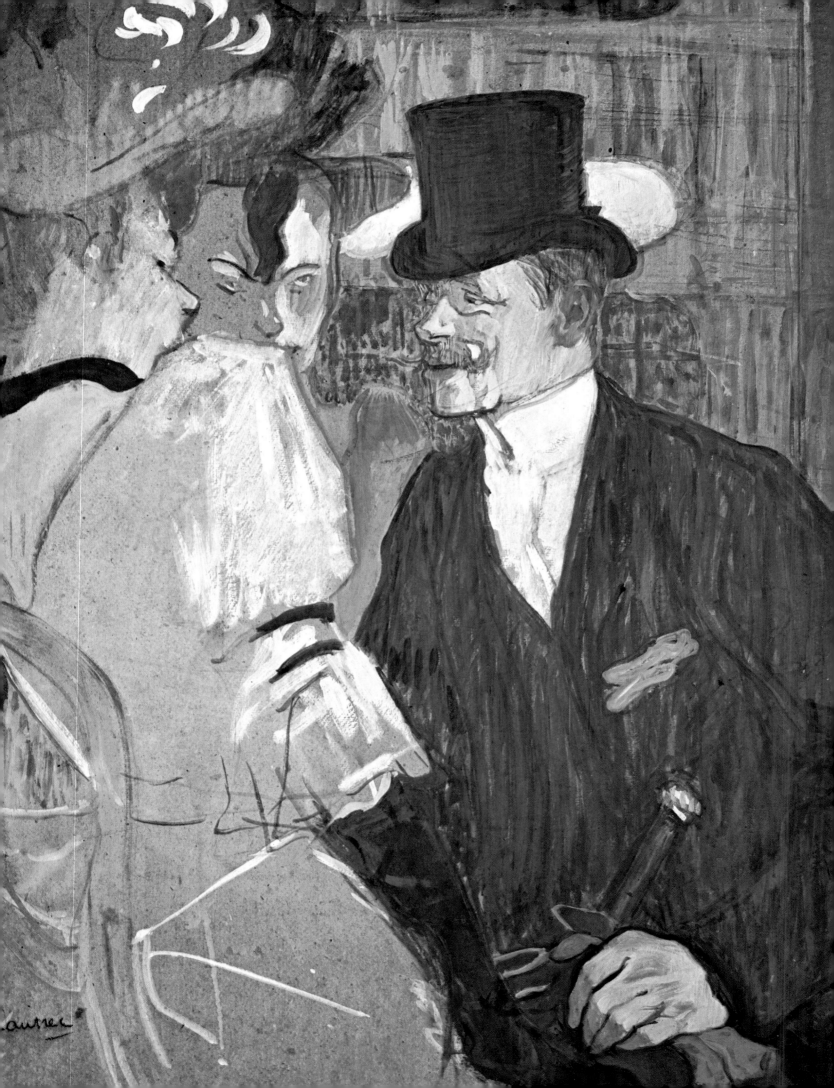

Life is a Cabaret
1892 - 1898

An Englishman, armed to the teeth with cane, top hat and winning charm, is flirting with two coquettes at the "Moulin Rouge". The formality of his clothing and bearing is contrasted with the merely suggested subtlety of the women's rig-out. Yet a handful of sketched-in details – the black neck-band, the low-cut back of the dress, the postures of the women (who are seen half from the rear) and the animal slant of their eyes, and the pert strand of hair on the forehead of one of the women – leave us in no doubt as to the nature of these ladies. The artist has found it necessary to provide greater detail in the case of the Englishman, with his elegant front: his demeanour suggests he is lying in wait, his ears have a reddish look, his hand lacks its wedding ring, and his facial expression, that of a pleasure-seeker putting on a debonair, easy-going show (caught in a few vigorous lines), all betray the deal he is intent on negotiating, and the sensual anticipation that characterizes this wolf in sheep's clothing.

The preliminary study (left) has a spontaneity that is close to genius. In the coloured lithograph of the same subject, by contrast, Toulouse-Lautrec presents the Englishman as a violet silhouette with only a few lines picking out his jacket, and uses this silhouette technique to express the contrast between the figures, which in the lithograph is conceived as a poster and is not necessarily more successful. In the stylized graphic version (see the monochrome state at right), too much has become over-definite and stiff, while the study preserves the vital spontaneity of the moment.

Toulouse-Lautrec was so fascinated by the night life of Montmartre that after 1884 he made his home in that part of the city, at the very source of his material, as it were. Reacting against the pretensions and arrogance of his family, he preferred the natural ordinariness of the people, from all walks of life, who lived out their instinctive lives in Montmartre. In this sense, the picture of the Englishman at the "Moulin Rouge" can be seen as a kind of indirect self-portrait. The aristocrat well knew the sensuality and lust that were concealed behind the lordly façade of the man of the world. The artist had scant success with women, on account of his stunted physical form, and necessarily took something of an outsider's view of those healthy fortunates who had fun,

The Englishman at the Moulin Rouge, 1892
Monochrome lithograph, 47 x 37.3 cm
Private Collection

"I don't give a fig for the play. No matter how bad the show, when I go to the theatre I always enjoy myself." TOULOUSE-LAUTREC

LEFT:
The Englishman at the Moulin Rouge, 1892
Oil and gouache on cardboard, 85.7 x 66 cm
Metropolitan Museum of Art, New York

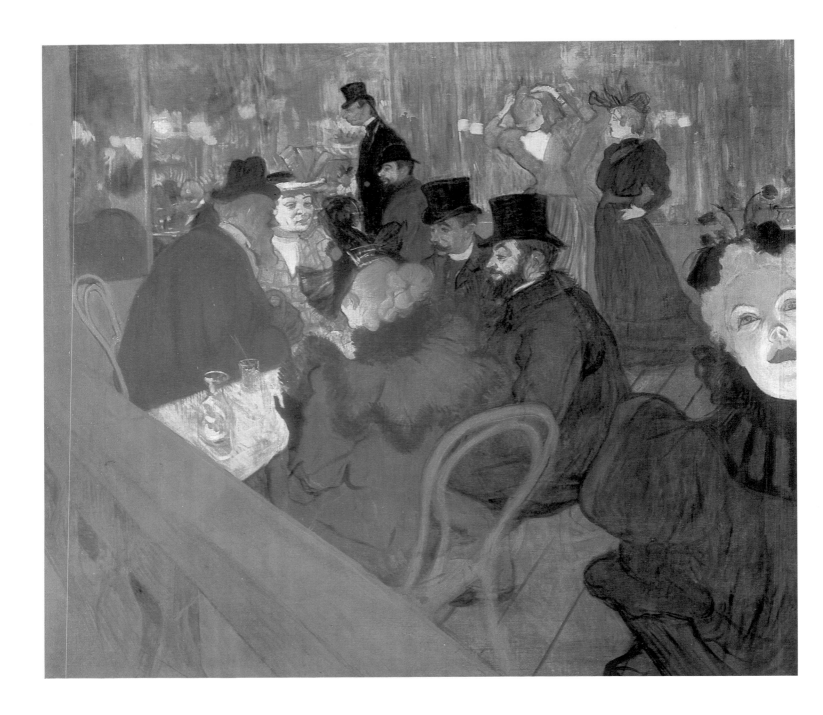

At the Moulin Rouge, 1892
Oil on canvas, 123 x 140.5 cm
Art Institute of Chicago, Chicago

RIGHT:
**La Goulue Entering the Moulin Rouge
Accompanied by two Women, 1892**
Oil on cardboard, 79.4 x 59 cm
Museum of Modern Art, New York

enjoyed their youth and money, and relished the pleasures of the flesh. Toulouse-Lautrec's addiction to the clubs and bars of Montmartre was partly a matter of taking his mind off things and numbing the loneliness that so easily arose once he confronted his extreme situation.

Cabaret life had become his main subject, and he fed his visual appetite every evening with new stimuli and scenes, always with people at their centre, people who tended to reveal their true natures only under the influence of alcohol or on the dance floor. Toulouse-Lautrec enjoyed watching vitality and energy, beautiful women, the flashing lights and colours of a world that was so artificial and yet, at a deeper level, perhaps truer and more honest since it was less inhibited. He found what he was after in places that other artists rejected or thought

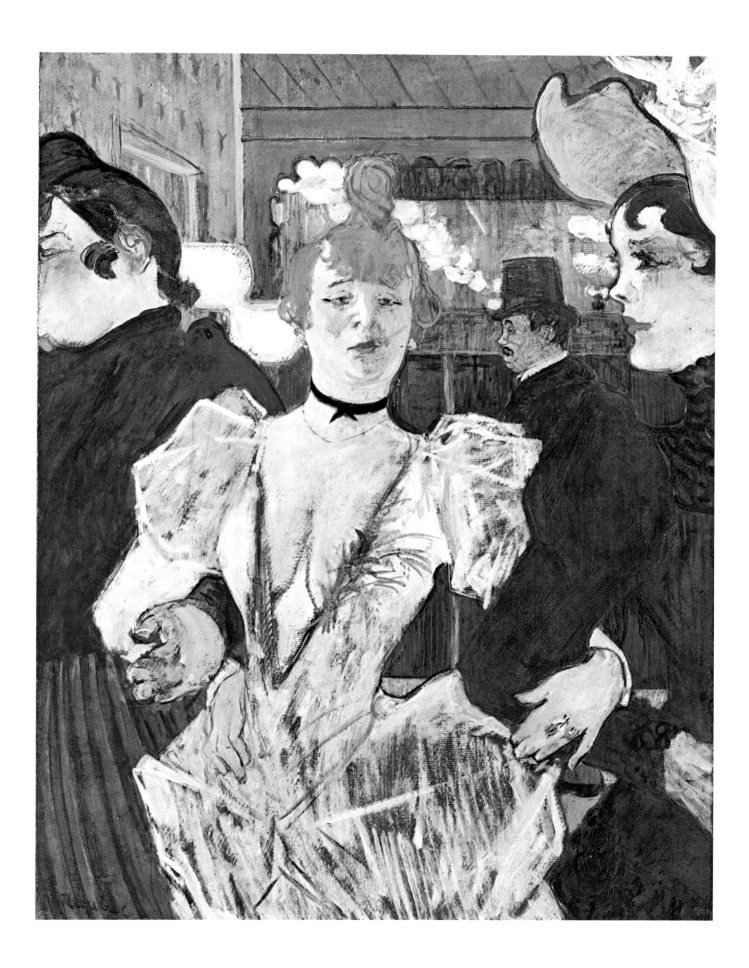

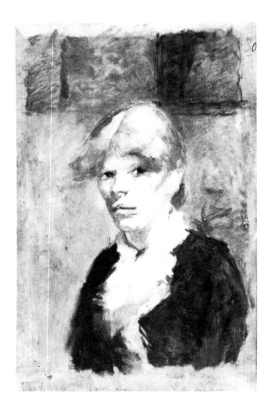

Carmen Gaudin, 1884
Oil on cardboard, 23.9 x 15 cm
Musée Toulouse-Lautrec, Albi

"I was always struck by the way Lautrec changed his way of talking when art was being discussed. On any other subject he was cynical and witty, but on art he became totally serious. It was like a religious belief for him." EDOUARD VUILLARD

**At the Moulin Rouge:
The Start of the Quadrille, 1892**
Oil and gouache on cardboard,
80 x 60.5 cm
National Gallery of Art, Washington

scandalous. In the spirit of Zola and with a meticulously dissecting gift of vision, he sought out the places and situations that had never before been thought worthy of treatment by artists.

In the early 1890s, the "Moulin Rouge" and its stars provided Toulouse-Lautrec with a near-inexhaustible source of inspiration for masterpieces. In one painting now in New York (p. 51), La Goulue, whom he had immortalized the year before on his first poster, is seen entering the "Moulin Rouge" wearing a daringly décolleté dress. The edges of the picture cut away the two companions she has linked arms with: as was probably the case in life as well, they merely serve to provide the dancer with support as she makes her entry. A bulldog-like man in a top hat is crossing behind them and , together with the lamps receding in the mirror, he adds a sense of depth perspective. The picture is composed wholly in cool and carefully graded tones of blue-green, with only a few highlights of brown and orange. The painting is totally dominated by La Goulue's bearing and facial expression, as if to say: Look here, this is a star arriving.

A similarly striking moment is captured in another picture of 1892, "At the 'Moulin Rouge': The Start of the Quadrille" (right). Legs apart and dress gathered up, a dancer (La Goulue?) is all set to perform, while in the foreground a couple of customers, who have clearly just arrived, are crossing the floor for a place. The position of the dancer's legs and arms, and her somewhat stupid facial expression, doubtless signal the beginning of the quadrille but also a certain displeasure at the delay as well as frivolous self-confidence.

Toulouse-Lautrec has here captured a highly ambiguous moment with great skill. It is a moment snatched from the confusion of green and orange lighting, a moment that would strike a less alert eye es unremarkable; Toulouse-Lautrec has caught movement, registered the unrepeatable event as if in a snapshot, and through artistic exaggeration has given permanence to the whole. He has even anticipated certain shots that were to become familiar through film camerawork. Technically speaking, this, like so many other oils by the artist, is marked by an economy that has something of genius about it: indeed, the shades of orange have largely been provided by unpainted areas of cardboard (which today has probably darkened with the years). The coat that the woman in the foreground is wearing (we see her at an angle from the rear) is suggested by just a few blue and brown brush-strokes together with unpainted surfaces, and the effect is a very neat characterization. The intermediate area and background are brought alive with unpainted areas too, which contrast attractively with the predominant pale green.

Another large composition done the same year (and later added to and improved by extra pieces joined on at the bottom and right) shows a different location and mood: the "promenoir" of the "Moulin Rouge" (p. 50). It is painted on canvas and is one of the artist's most thoroughly achieved works. Customers, acquaintances of the artist's, are sitting at a diagonal bar that crosses the foreground at left, talking at a

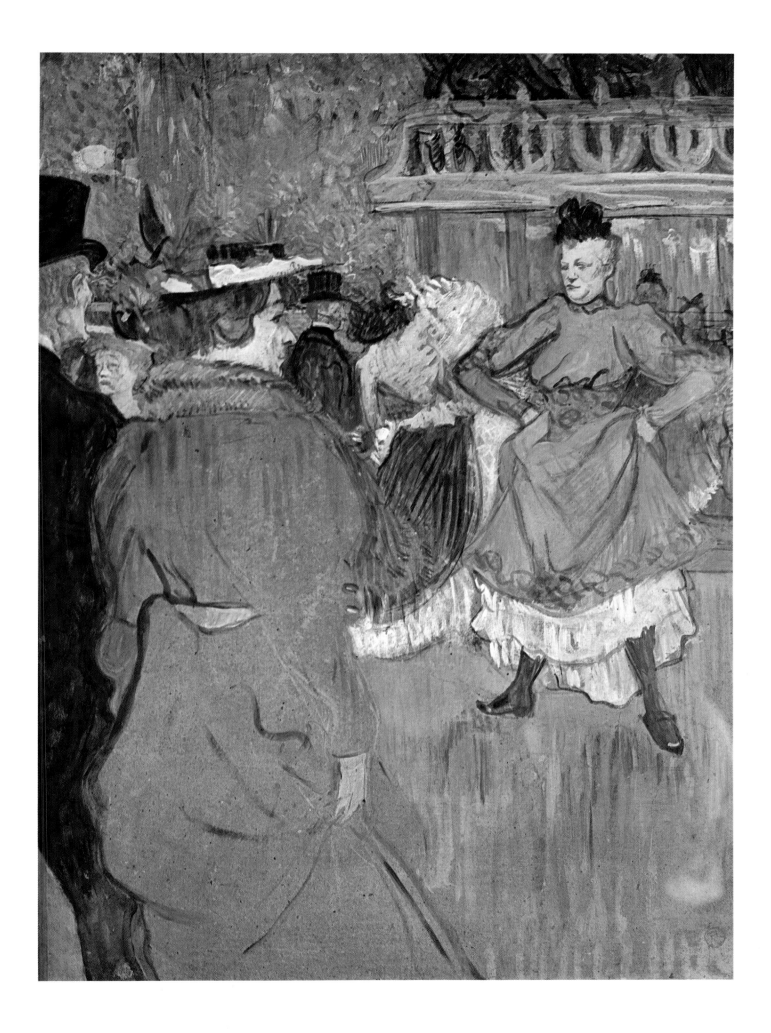

Cartoon self-portrait at the easel
Pen drawing
Musée Toulouse-Lautrec, Albi

"Ugliness always and everywhere has its enchanting side; it is exciting to hit upon it where no one has ever noticed it before."
TOULOUSE-LAUTREC

At the Moulin Rouge:
Two Women Dancing, 1892
Oil on cardboard, 93 x 80 cm
Národní Gallery, Prague

table – two women and three men. To the right in the foreground the face of a woman dressed in dark clothes (Jane Avril?) is dazzled by the light, and the green shadows in the upper part make the face appear like a mask. In the background La Goulue and a woman friend are doing up their hair in a mirror, while behind them little Toulouse-Lautrec and his tall cousin and friend Gabriel Tapié de Céleyran, a perfect Sancho Panza and Don Quixote, are crossing the room.

Toulouse-Lautrec loved making comic appearances in bars with this relative of his. Of course he could scarcely have seen himself in the position he is seen in here, in this most detailed of compositions – in profile. But he imagined the way he looked to others and painted it, and in doing so was merciless towards himself. At the same time, his position among the other people in this picture is typical of his role in life: while the others have fun and chat, Toulouse-Lautrec hovers on the fringe, simply an outsider in the scene, an extra, even a voyeur to be put up with.

In the years following its opening in 1889, the "Moulin Rouge" became the most popular night-spot in Montmartre, thanks to the stars it billed and its lavish and wittily original décor. The red mill, which still stands on its side at the Place Blanche and which was originally designed by Willette, was merely a façade and as such alluded to the many real windmills that had previously existed in Montmartre, one of which, the "Moulin de la Galette", had become a dance club. In the garden of the "Moulin Rouge" there was an outsize elephant, bought at the 1889 Paris World Exhibition, in the inside of which curios were displayed. As you entered the club, you saw Toulouse-Lautrec's "Cirque Fernando: The Equestrienne" hung against red velvet. The heart of the club was the dance hall with its galleries, where the performances took place. A table was permanently reserved for the artist there, and most evenings he was to be seen at it. What amused him was the mixture of trivia and art, elegance and sensuality.

La Goulue (the glutton) had been given her stage name because of her supposed habit of draining guests' glasses. Some of her less well-known colleagues had nicknames which were even cruder or more ambiguous: La Torpille (Electric Ray), Grille d'égout (Drain-cover), Nana-la-Sauterelle (Nana the Grasshopper), Georgette-la-Vadrouille (Georgette the Tramp), Demi-Siphon (Half-Siphon) and Rayon d'or (Ray of Gold). One name that was a direct contrast to the vulgarity of La Goulue's nickname was that of her distinguished colleague Jane Avril, who was known as La Mélinite (High Explosive), not so much on account of her personal charms as her stage act. At first she was part of the quadrille line at the "Moulin Rouge" but then she established her own act, and proved her talent not only in her performing and choreographic artistry but also in her own designs for costumes.

Jane Avril and Toulouse-Lautrec were good friends. In addition to the posters, he made a number of paintings showing the dancer during or after her "Moulin Rouge" act. One is a vertical-format piece showing the slender artiste dancing caught at the moment

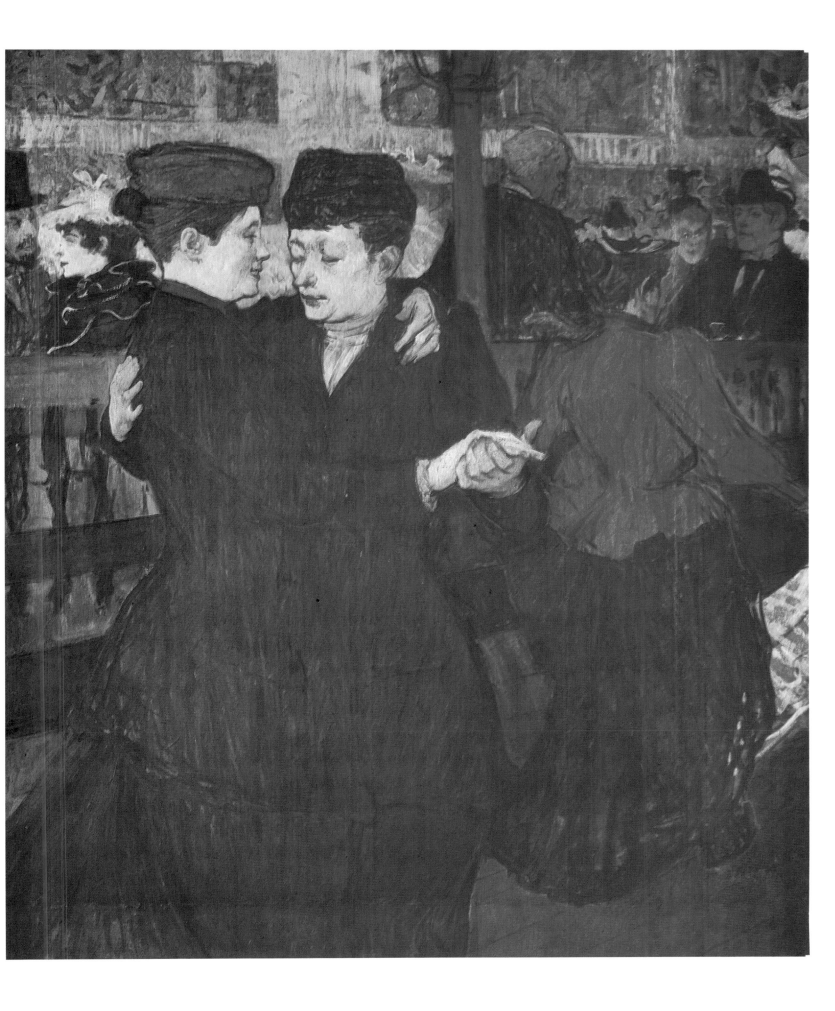

Jane Avril leaving the Moulin Rouge, 1893
Oil and gouache on cardboard,
84.3 x 63.4 cm
Wadsworth Atheneum, Hartford (Conn.)

when, standing on one leg and gathering up her white dress, she is kicking up her other leg in the **port de bras**. Her surroundings are merely suggested by loose brush-strokes. Once again, perspectival depth is implied by lines running diagonally and by a couple of onlookers in the background where the sight-lines converge. Another of Toulouse-Lautrec's devices, one which he often employs elsewhere, is apparent here with particular clarity: the vanishing-point, customarily located around the centre of a picture, is re-located at one side, indeed sometimes he places it beyond the edge of a picture. This device, adopted from Japanese practice, was a novelty in European art and made it possible to use abrupt perspectives and unusual angles of vision in order to lend greater emphasis to the subject. In other works, such as the "Moulin Rouge" picture (p. 50), Toulouse-Lautrec even went so far as to incorporate two different and diametrically opposed perspectives in a single picture, with the effect of suggesting great space and the liveliness of the club.

Also in 1892, he painted two of the more private pictures of Jane Avril. One (Courtauld Institute, London) shows her with coat, hat and gloves at the cloakroom. With a relaxed and introvert air she is getting ready to go home. The other (right) shows her lost in thought as she leaves the "Moulin Rouge" and the merry hustle and bustle. Her sobre, lady-like attire, dark and unrevealing, done by the artist in vertical strokes, contrasts with the tawdriness of her surroundings; Toulouse-Lautrec succeeds brilliantly in conveying the polarity of an individual's inner mood and the outside atmosphere. The artist's personal involvement and sympathy come across clearly. Indeed, these pictures are declarations of love – in paint – for a woman who was perhaps understood by no one but Toulouse-Lautrec, with his highly sensitive alertness to what was essential and unique in people. These two people, physically so unlike, were at one in their melancholy.

Toulouse-Lautrec was at his remarkable best with portraits when he knew his sitters well, as friends. At the start, when he had yet to make his mark, he portrayed professional models or girls he saw on the streets, in the most various of settings. And in the 1880s he painted masterly portraits of Carmen Gaudin (p. 52), who was known as La Rosse (The Slut), Rosa-la-Rouge (Red Rosa), Hélène Vary and Suzanne Valadon (p. 24). The painting of Justine Dieuhl (p. 61), done in 1890 in "Père" Forest's Montmartre garden, is a later example of this kind of portrait. One or two other portraits were painted in the same place, among them that of Désiré Dihau. What is unusual in these, given that they are works of the artist's maturity, is the landscape background and the fact (as photographs show) that Toulouse-Lautrec painted out of doors.

Some years later, he visited the châteaux of the Loire with friends who drew his attention to the natural beauty of the scenery there (no doubt to encourage him to try his hand at landscape painting), but Toulouse-Lautrec vehemently rejected the landscape art of the Impressionists. In his rigorous concentration on the human figure, Toulouse-Lautrec remains one of the most extreme (and consistent) artists

"Only the figure exists. Landscape merely is, and must not be anything more than an addition: the pure landscape painter is a barbarian. Landscape should only serve to help us understand the character of the figure better. Corot is great only on account of his figures, and the same is true of Millet, Renoir, Manet and Whistler. When figural painters do landscapes they treat them as they would treat faces. Degas's landscapes are incredible because they are human masks! Monet has abandoned the figure, but what might he not have achieved with it!" TOULOUSE-LAUTREC

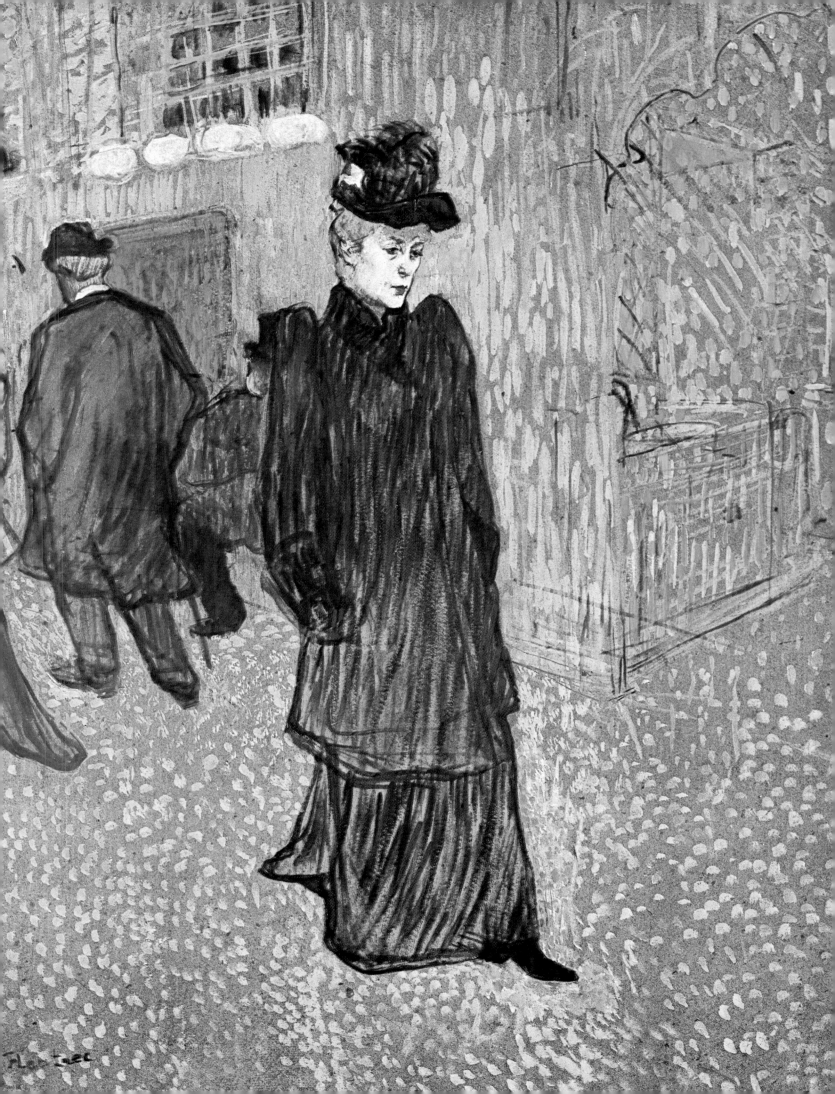

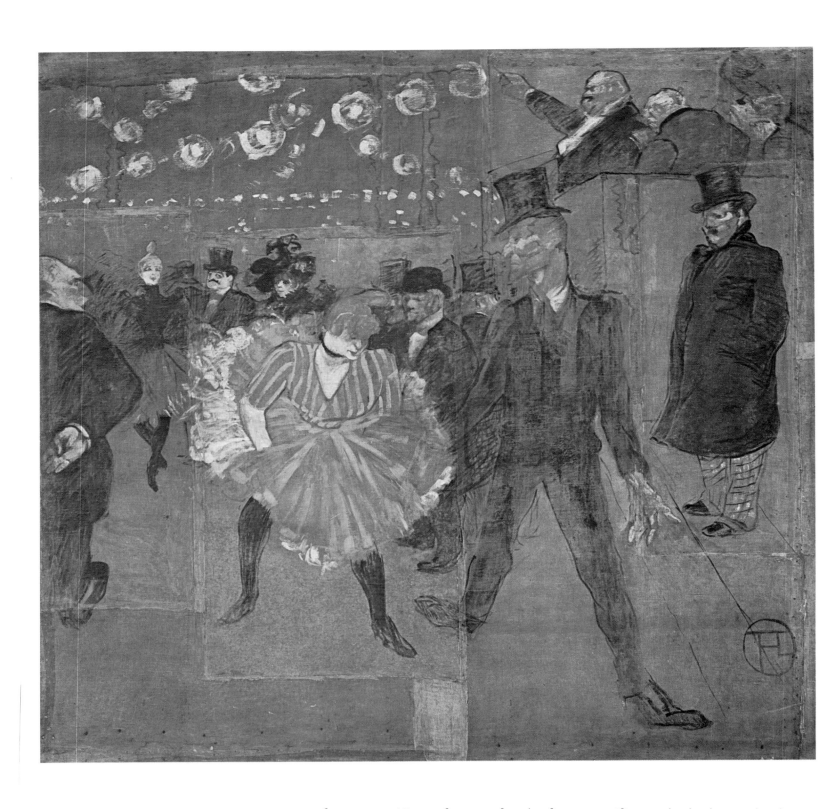

La Goulue Dancing with Valentin-le-Désossé, 1895
Oil on canvas, 298 x 316 cm
Musée d'Orsay, Paris

"Ha! I should like to see the woman on this earth who has a lover uglier than me."
TOULOUSE-LAUTREC

of any age. His preference for the figure testifies to the high standards he set himself. Like Degas, whom he admired, he viewed his few pastel landscapes as exceptions to his own rule, and when he departed from the human figure, he preferred to do so only to paint animals, preferably horses.

Thus the portrait of Justine Dieuhl is something of an exception, though the landscaped garden background is by no means merely a backdrop but rather, in a manner that almost anticipates the

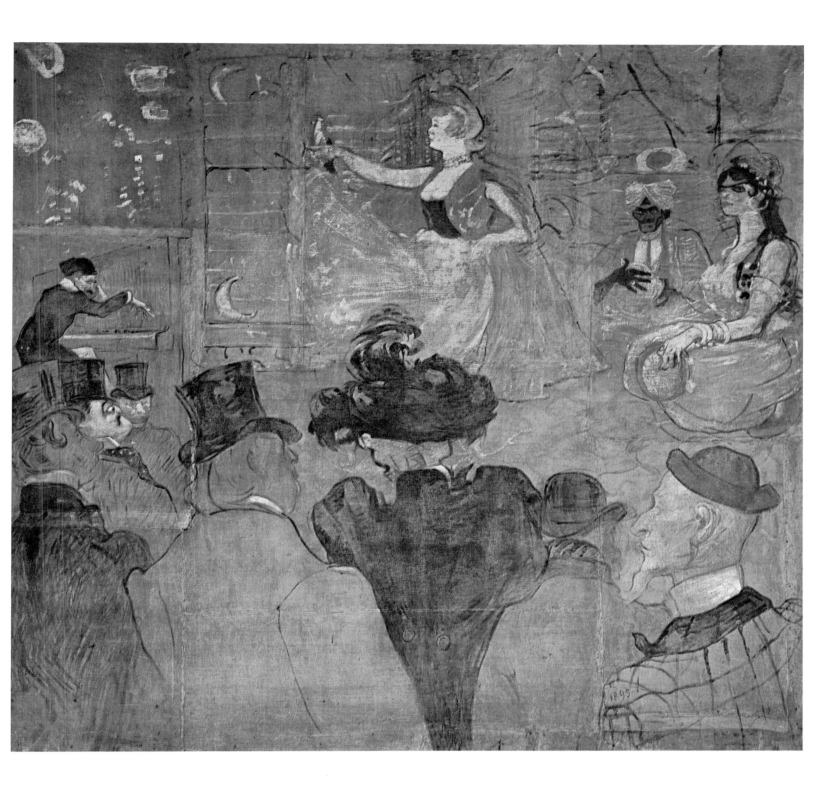

Expressionists, serves to amplify our grasp of the sitter's character. Toulouse-Lautrec liked in general to show his subjects in a typical setting, especially if they were friends. Thus he pictured his cousin Gabriel as a full-length figure, elegantly dressed, pacing the foyer of the Comédie Française during the interval, lost in thought, leaving the gossiping crowd behind (p. 63); or the actor Henry Samary on stage (once again the picture has two vanishing-points!), doing his act in front of a painted backdrop (p. 25). He showed his other cousin, lady's man Louis Pascal, as

La Goulue Dancing ("Les Almées"), 1895
Oil on canvas, 285 x 307.5 cm
Musée d'Orsay, Paris

"One is ugly oneself, but life is beautiful."
TOULOUSE-LAUTREC

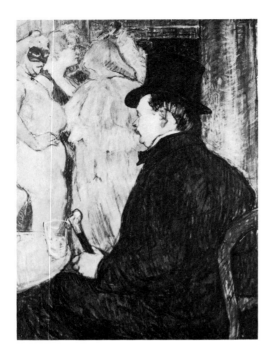

Maxime Dethomas at the Opera Ball, 1896
Oil on cardboard, 67.5 x 52.5 cm
National Gallery of Art, Washington

Justine Dieuhl, 1890
Oil on cardboard, 74 x 58 cm
Musée d'Orsay, Paris

a dandy in a top hat and carrying a cane, all set to go out (Musée Toulouse-Lautrec, Albi).

Once he told his painter friend Maxime Dethomas: "I shall record your immobility amidst the fun of the dance." The painting that resulted (left) is a masterpiece, showing the painter's friend in a dark coat and hat sitting stiffly with his stick watching the bright, colourful creatures at the opera house ball. The artist must have known his subject intimately to reproduce his character so well in paint. The portrait of another friend, Tristan Bernard (private collection, New York), a writer and manager of two Parisian cycling racetracks, shows the subject on the track of one of the velodromes. That of the young critic Paul Leclercq (who was later to write on the artist) shows him in a wicker chair in the studio (Musée d'Orsay, Paris). As for the scandalous Oscar Wilde, who refused to sit for Toulouse-Lautrec, he appears – in a portrait done from memory – as a bloated monster with a pretentious and sour gaze: the artist has taken his revenge for the writer's churlish refusal (private collection, Beverly Hills).

Toulouse-Lautrec undoubtedly suffered greatly from his physical condition, and as a sort of self-defence he developed a special kind of irony directed at himself. His appearance was certainly unusual, as many photographs and portraits by artist friends show, but it was by no means as frightful as he saw himself in numerous cartoons (p. 54). In conversations and in his letters, too, he generally referred to himself in sarcastic and disillusiond tones. It was a way of getting in ahead of potentially hurtful remarks and robbing them of their edge: he owned up to all his weaknesses himself and thus deprived sadistic mockers of their ammunition. No doubt his predilection for masks and costumes also resulted from his desire to be (or at least appear) other than he was. When we look at photos of the artist in the 1880s in particular we find him time after time at costume balls, often dressed in bizarre style as a choirboy, a woman, or a squinting Japanese in a kimono. At the same time he loved and admired everything that for him remained unattainable: beauty, physical strength and mobility, acrobatic skill. If anything was beyond him he aimed to feel his way into it, through his art, and so creativity for Toulouse-Lautrec represented a substitute for the life he could not lead himself. And precisely because he was excluded from so much, his sensitivity was all the more intense, his eye all the clearer.

His friends are unanimous in their testimony to his ready wit. To win social acceptance in spite of his physical appearance, Toulouse-Lautrec cultivated a vein of amusing originality that issued in characteristic turns of phrase and funny word-play, and in a love of the trivial and even the obscene. He recognised very few taboos among friends, and frequently shocked people (especially simple, petit bourgeois people) with his subtly adopted pose of naive openness. Sociable and something of a gourmet, Toulouse-Lautrec was amusing and readily amused, quick to see unintended humour or paradox in a situation. Only one thing was sacred to him: art. Art was the very heart of his existence. He needed art

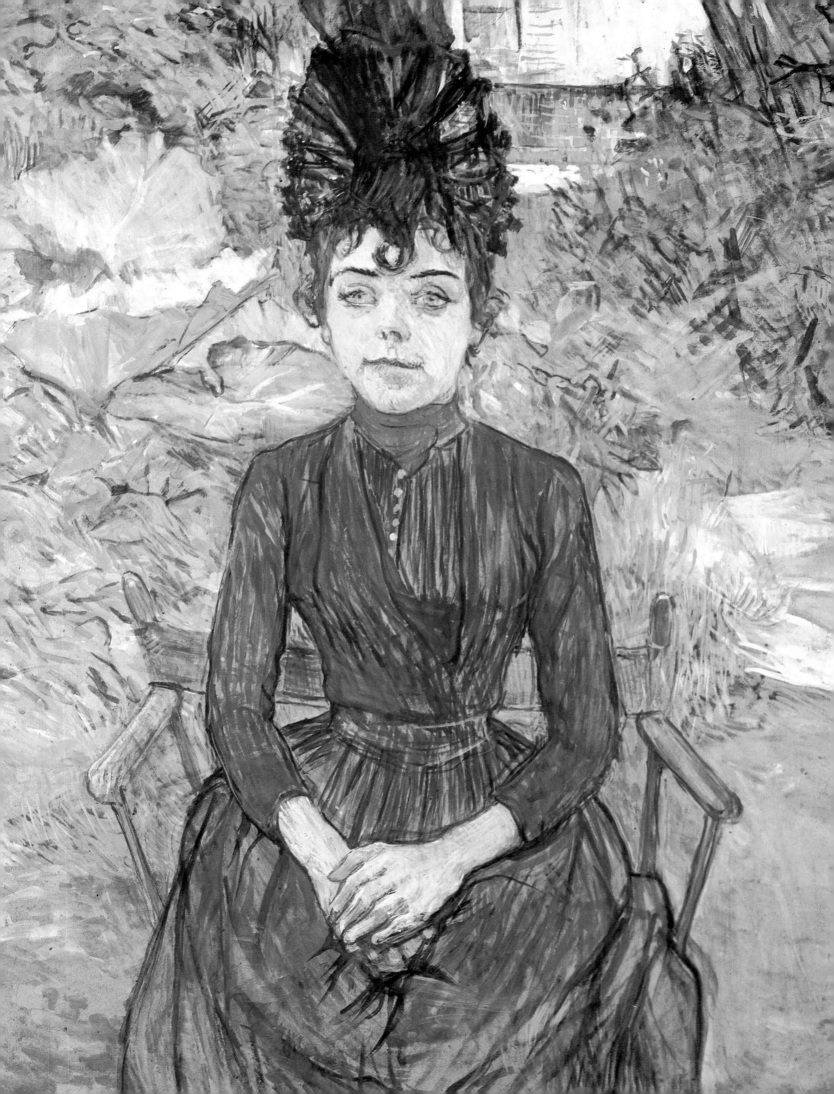

An Interne: Gabriel Tapiè de Céleyran, 1894
Pen, 33 x 22 cm
Musée Toulouse-Lautrec, Albi

"If I were not a painter, I should like to be a doctor or a surgeon." TOULOUSE-LAUTREC

Dr. Gabriel Tapié de Céleyran, 1894
Oil on canvas, 109 x 56 cm
Musée Toulouse-Lautrec, Albi

to live – and, conversely, he was greedy for the life he needed to use in his art.

Toulouse-Lautrec attended his theatre of life not only in cabarets and café-concerts but also in the bars he visited most nights. Two of his favourite bars, the "Weber" and the "Irish and American Bar", were not in Montmartre but in the Rue Royale. There he could meet not just artists but also sportsmen: famous jockeys attracted him and he showed them in a number of painted and graphic works. The most important of these is probably the monochrome lithograph "The Jockey" (1899), which also exists in a number of versions hand-coloured by the artist (p. 83). The impact of this picture, dynamic enough with its two riders galloping away on horseback, is further increased by the energetic colours. This lithograph, one of Toulouse-Lautrec's masterpieces, is finer even than Degas's fine pictures of jockeys.

What drew the artist to the jockeys was of course their physical ability and power, and similar reasons attracted him to circus artistes and entertainers. He could meet them in the "Irish and American Bar". One pair of clowns, Footit and Chocolat, intrigued him in particular, and he showed them performing their act in numerous lithographs, drawings and studies. The black (known for obvious reasons as Chocolat) is seen in one drawing (p. 64) performing an elegant dance, lithe as a cat, in the "Irish and American Bar". With the bony, macabre silhouette of Valentin, this exotic figure, pictured with an exaggeratedly ape-like quality, is one of Toulouse-Lautrec's few male models that have any of the memorability of his countless women. The scene is also striking for its anticipation of the socio-critical art of a later time, especially in Germany – it could be straight out of Bertolt Brecht's **Threepenny Opera**.

Other types caught the artist's attention in the bars of Paris, such as the corpulent drinker with the sandy walrus moustache seated next to the anaemic barwoman (p. 67). This oil study, done with sure brush-strokes on cardboard, is reminiscent of Daumier or Heinrich Zille. The old Dutch subject of the unmatched couple had attracted Toulouse-Lautrec in his early masterpieces "A la Mie" and "Reine de Joie"; here, what he emphasizes is not so much the aggression that alcohol prompts, or the marketability of love, but rather convivial tipsiness and indifferent business sense viewed side by side.

What we have now come to call a sub-culture was Toulouse-Lautrec's preferred field. For instance, a number of lesbian establishments that normally kept their doors closed to men welcomed the artist in. One-eyed Madame Armande, who presided over the takings at "Le Hanneton" (The Cockchafer) in the Rue Pigalle, was immortalized in a coloured lithograph of 1897, while Palmyre, the owner of "La Souris" (The Mouse), kept a bulldog called Bouboule which dog-lover Toulouse-Lautrec depicted in drawings, oil sketches and lithos.

The subject of lesbian love seemed to exert a special power over the artist, who was indeed generally interested in departures from the sexual norm. The clowness Cha-U-Kao, who appeared at the "Moulin Rouge", and whom Toulouse-Lautrec repeatedly portrayed (p. 2),

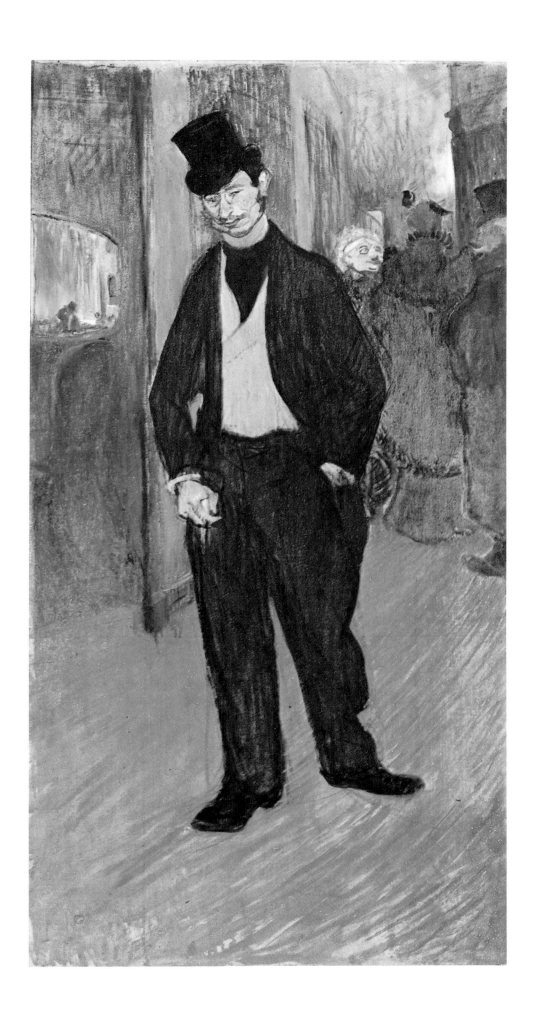

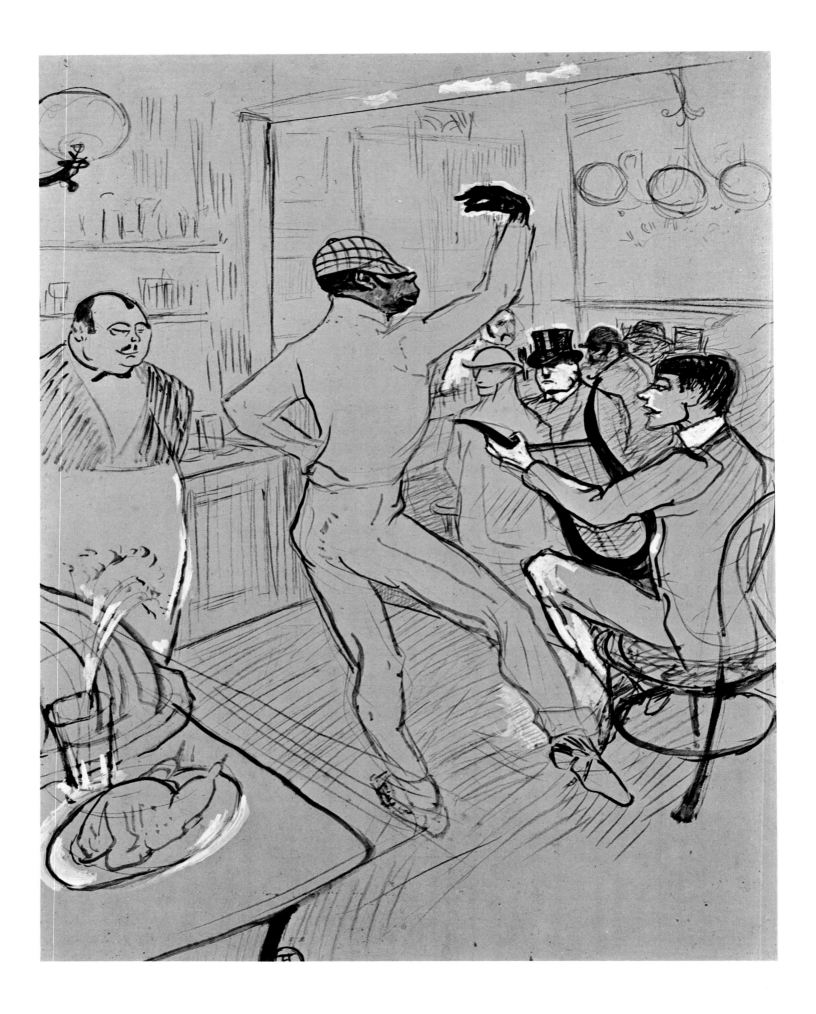

doubtless fascinated him because her departure from the norm was twofold: on the one hand a woman was playing the classic male role of clown, and on the other she was a woman who loved women. A more private picture, as it were, shows her dancing a waltz with a woman friend, in a work of feeling and intimate character (p. 55). Toulouse-Lautrec's "Elles" series of coloured lithographs opens with Cha-U-Kao the female clown, quasi-programmatically, as if to insist that these too are women: a lesbian clowness and brothel girls.

Toulouse-Lautrec's models, whether famous or unknown, all led their own lives; and when the stars – such as Bruant, Guilbert or Avril – grew old, they wrote their memoirs, and often had things to say about the painter. Some of them were in the limelight for only a few years. La Goulue's fall from stardom to obscurity was especially rapid, and as early as 1895, grown fat, she was to be seen doing her turn at fairgrounds. In that year she approached Toulouse-Lautrec with a request for two large painted curtains for the booth where she performed, and the artist rose to the occasion with two immense, square, unprimed canvases showing La Goulue yesterday and today: in one (a variant on the "Moulin Rouge" poster) she is dancing with Valentin, in the other she is seen performing her new act, a Moorish dance (pp. 58 and 59). In the latter picture, with their backs to us, we can identify Oscar Wilde, Jane Avril, Toulouse-Lautrec himself, and the critic Félix Fénélon among the audience – which doubtless flattered La Goulue and briefly buttressed her collapsing reputation. These two "functional" works of art naturally suffered during years of fairground wear and tear, wind and rain; and, as if that were not enough, a businesslike art dealer later cut the two curtains into a number of pieces to be sold separately. It is little short of a miracle that the Louvre conservation team was able to piece the puzzle back together again.

Few other artists so faithfully reproduced the life of the people and places around them. For Toulouse-Lautrec, life was one big theatre to be passionately enjoyed, a cabaret, a circus, a fairground, where the variety and contradictions, the instincts and the inhibitions, the limitations and the ambition of genius, goodness and wickedness, exhibitionism and introversion, sophistication and naivety, youth and age, happiness and melancholy, were all to be found. It was reality that Toulouse-Lautrec so hungrily sought and absorbed, reality that he so vitally and persuasively expressed. Weak in constitution and health, he was addicted to energy: "Ah, life, life!" he is said to have often exclaimed. His appetite for the diverse scenes of life was matched by his appetite for great works of art – though few painters of the past or present met with the approval of this sternest of critics. When he visited a gallery (such as in Brussels) Toulouse-Lautrec could stand before a single picture for hours and ignore everything else on show. His love of life and art alike was passionate.

His family fortune gave him financial independence, so Toulouse-Lautrec had no need for success and sales. With the exception of a handful of enlightened critics (such as Arsène Alexandre, Gustave

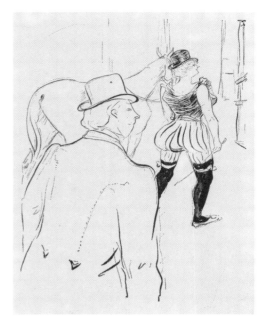

Behind the Scenes at the "Folies Bergère", 1896
Indian ink and blue chalk, 65 x 50 cm
Musée Toulouse-Lautrec, Albi

Chocolat Dancing in the "Irish and American Bar", 1896
Indian ink, crayon and opaque water colour on paper, 65 x 50 cm
Musée Toulouse-Lautrec, Albi

In the Bar, 1898
Oil on cardboard, 81.5 x 60 cm
Kunsthaus Zürich, Zurich

Geffroy or Roger Marx), most people rejected his work in tones of indignation, incomprehension or ridicule. In 1896 Maurice Joyant, the artist's old school friend and an art dealer, organized a major exhibition at his Paris gallery. It was at this show that Toulouse-Lautrec for the first time exhibited (admittedly in a separate room to which only friends had access) a series of the pictures he had painted in Parisian brothels in 1893 – pictures which were considered risqué in subject matter and, as one outraged uncle informed his nephew, dishonoured the family name.

The subject of prostitutes and brothels did in fact have a tradition behind it, with the Impressionists and cloisonnists: we need only think of Manet's "Olympia" (1863; Musée d'Orsay, Paris) and "Nana" (1877; Kunsthalle, Hamburg), Degas's brothel monotypes (done around 1879), brothel pictures by Anquetin and Bernard dating from the late 1880s, and the interest van Gogh had already shown in prostitutes in his Dutch period. This is largely due to the influence of the Naturalist novelists Zola and the brothers Goncourt, and of Guy de Maupassant; all of them had turned to the subject before the painters did. A further influence on Toulouse-Lautrec, open as he was to all things Japanese, may have been Kitagawa Utamaro's pictures of courtesans.

Toulouse-Lautrec was delighted by the naturalness, lack of posing, naive triviality, sentimentality and humour of the prostitutes. He was able to win their confidence and was thus in a position to observe them in the brothels undisturbed. For a time he even moved into a bawdy-house, which outraged a number of acquaintances who came to visit, such as the prudish art dealer Paul Durand-Ruel. Though the artist loved pranks of this kind, his true reason for this change of scene was no doubt of an artistic nature: only if he grew intimately familiar with the whores' everyday life could he give a truthful and unprettified account of it in his art. As with the cabarets, he first needed to know the thing he wanted to paint.

His paintings, lithographs and drawings show prostitutes in various ways, always credible and without denunciatory or mocking tones. He showed them at ordinary business, killing time before or after a "customer": eating, playing cards, engaged in lesbian tenderness with each other. Tellingly, he never (apart from a handful of very private cartoons) showed them at their actual trade of selling love. For one thing, we can assume that the artist was scarcely welcome as an onlooker (another exclusion! – though an understandable one), and for another he did not want to risk being thought a producer of pornography. Brothels were tricky and scandalous enough as a subject; and plainly Toulouse-Lautrec knew he was ahead of his time with these pictures, which he carefully preserved for posterity. When he presented prostitutes or nudes, the images were not so much erotic as honest. What mattered more to him than a woman's seductive charms was to discover her nature and portray her everyday moods and way of life.

In 1893, as a sort of prelude, Toulouse-Lautrec painted a fairly harmless brothel interior: "Monsieur, Madame and the Dog." It shows the couple that run a house of pleasure, sitting on a red settee in

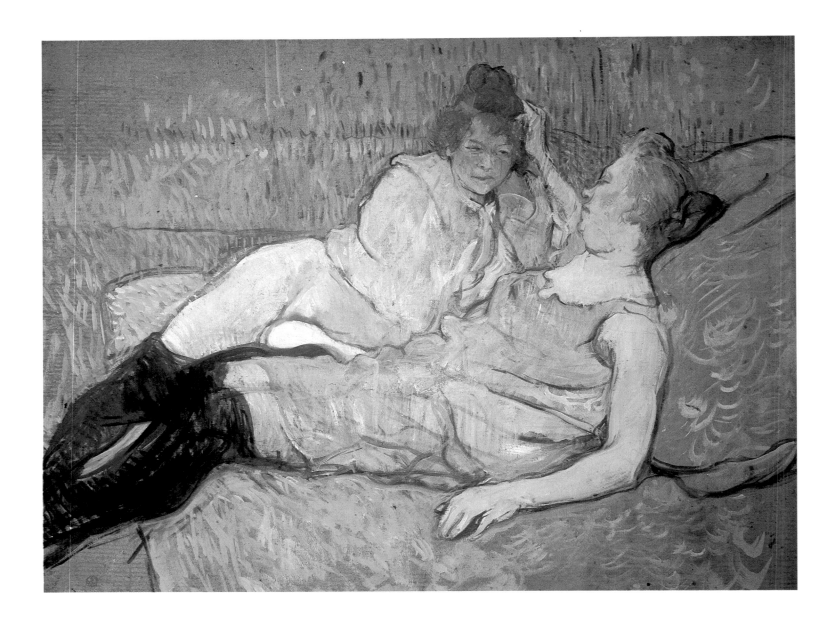

The Couch, 1894
Oil on cardboard, 63 x 81 cm
Metropolitan Museum of Art, New York

"All I hear is brothels! What of it? There's
nowhere I feel more at home."

TOULOUSE-LAUTREC

front of a mirror which reflects both them and the vague figure of one
of the house's girls seen from behind. What is exciting here is not so
much the actual theme as the novel artistic treatment, with its message.
The bright red-green contrasts render human types in brush-strokes of a
seismographic expressiveness, with a ready largesse that was not to be
attained again until Munch grasped it and took it further. Yet this
painting, so close to caricature, is also the picture which most clearly
shows Toulouse-Lautrec's debt to Daumier: we are reminded of his great
predecessor's waiting-rooms and third-class railway compartments,
where a similar mute resignation and petit bourgeois idiosyncrasy reign.

Because parts of the picture were left empty, works such as this
made an unfinished and therefore aesthetically unacceptable and invalid
impression on contemporaries trained in an academic tradition. The
artist countered this oft-repeated reproach with pithy, pointed
arguments that underline what was new in his aesthetic viewpoint. He
once said to his cousin Gabriel: "These people get on my nerves. They

want me to finish my works. But that is how I see things, so I paint them that way. After all, it is so easy to finish things. I can do you a Bastien-Lepage with no problem at all." And then, when he had promptly done a "finished" picture of this kind on the nearest canvas to hand, he turned back to his vis-à-vis and said: "See, that's how easy it is! There's nothing simpler than to finish a painting in an external sense. It's the very glibbest of lies."

The example of the old masters Rembrandt and Frans Hals (who in their own day were as much outsiders on account of their technique as Toulouse-Lautrec was in his), and unconventional pioneers such as Goya, Daumier and van Gogh, promted Toulouse-Lautrec to that realisation that was to revolutionize twentieth century art: that in distortion, and the use of approaches that had been seen hitherto as unaesthetic (such as leaving pictures "unfinished"), there were more suggestive and unplumbed possibilities and opportunities for conveying the truth than in

Monsieur, Madame and the Dog, 1893
Oil on canvas, 48 x 60 cm
Musée Toulouse-Lautrec, Albi

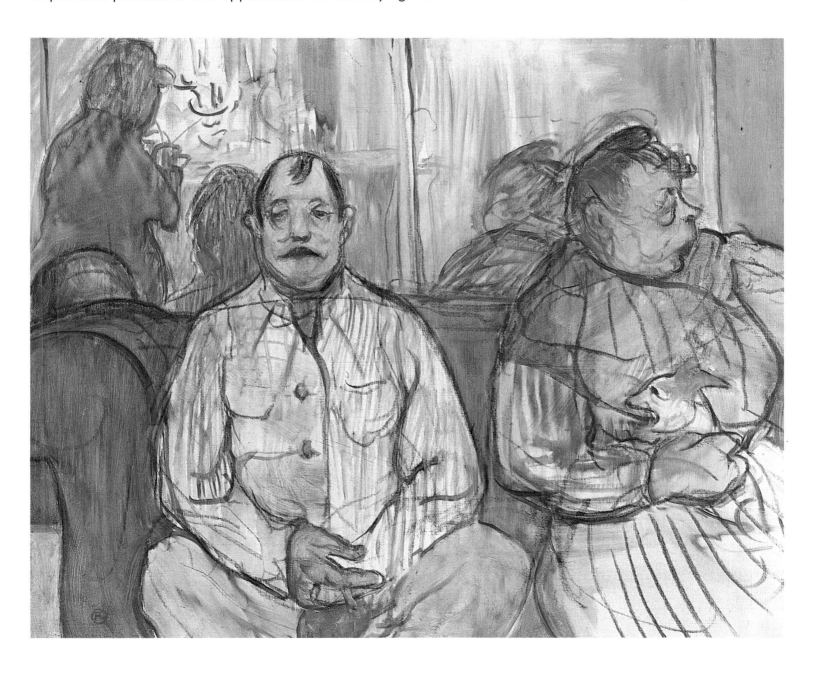

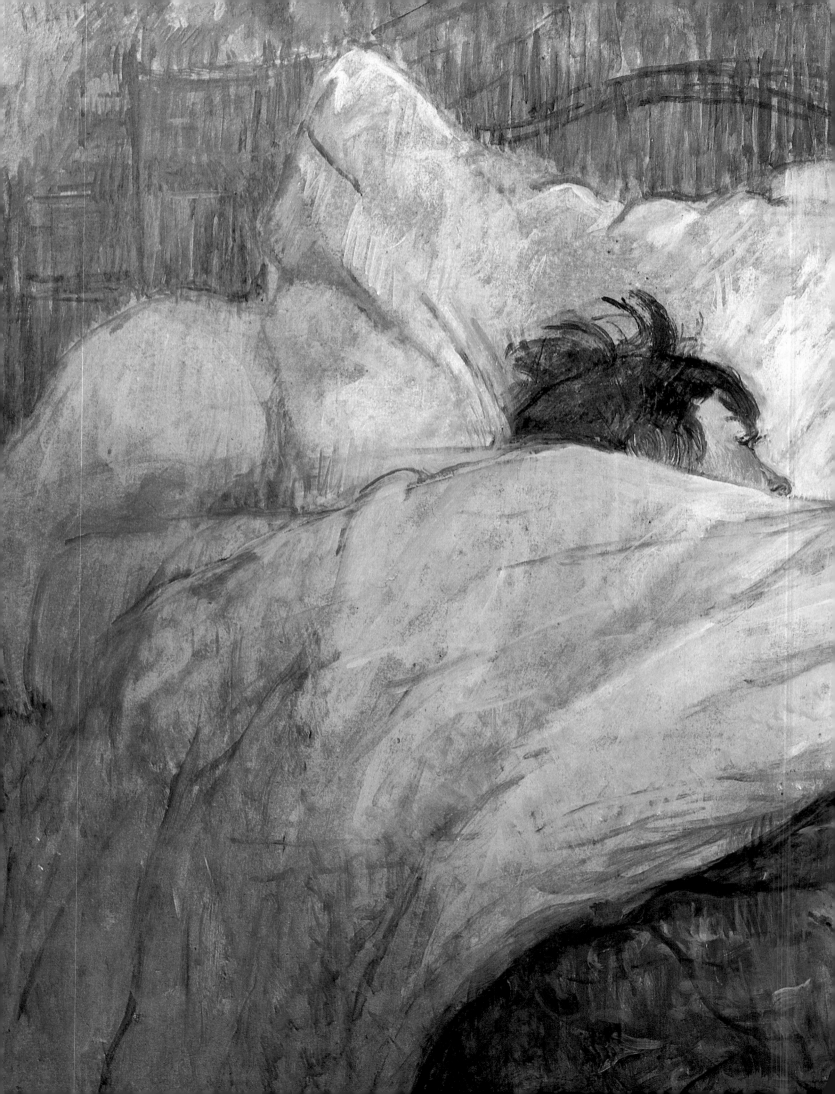

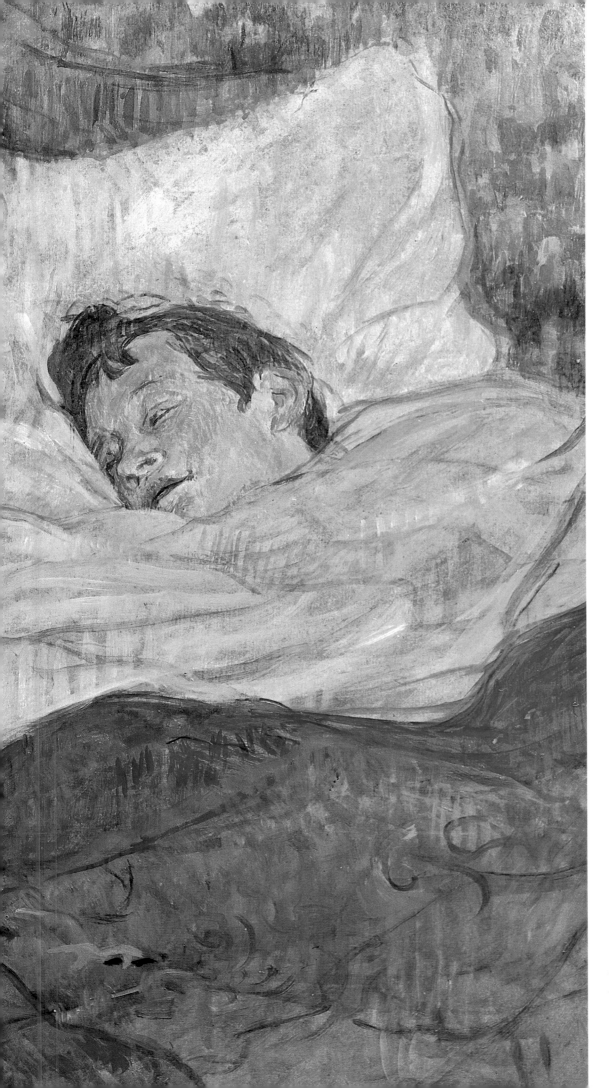

"Just imagine…When you see the way they love… eh? The technique of tenderness."

TOULOUSE-LAUTREC

In Bed, ca. 1893
Oil on cardboard, 54 x 70.5 cm
Musée d'Orsay, Paris

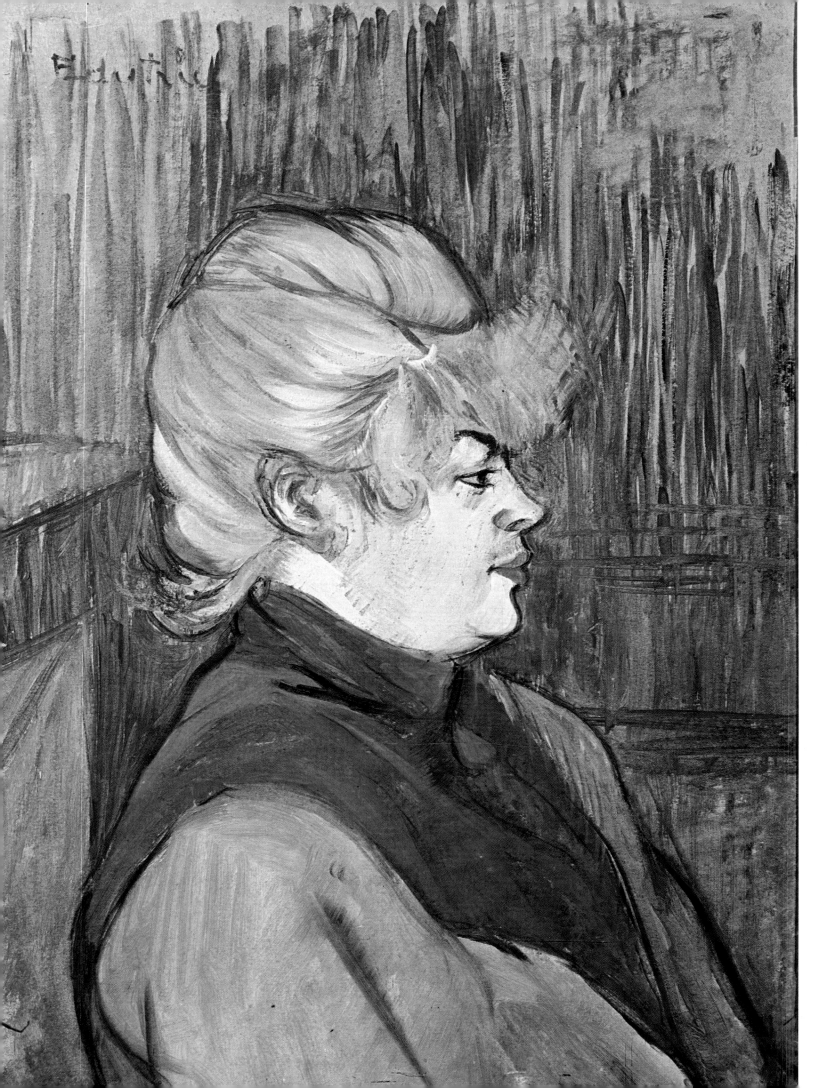

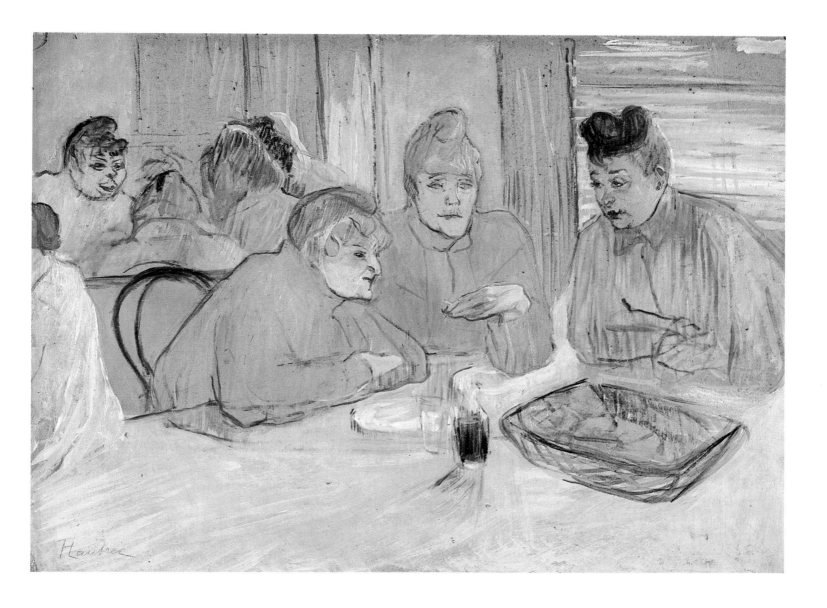

any form of accurate realism. On the other hand, the formal exaggeration and abstraction of a scene can indeed show its true essence, though more symbolically. Post-Impressionist Paul Cézanne held at that time that art was a "harmony running parallel to Nature". In the age of photography the task of painting can no longer be to provide an objective record of a thing or person. The work of art must show with greater intensity what the great old masters had already shown (in addition to merely reproducing given reality): a self-contained, independent world, a world of thought and feeling.

Toulouse-Lautrec devoted an entire series of works to the tender intimacies of whores. In what is perhaps the most successful of them, "In Bed" (pp. 70/71), we see the heads of two people in a double bed, almost totally covered by sheets and blankets and thus not immediately identifiable as two women. Yet what we see here is in fact two prostitutes lying cosily in bed, contented and secure together, gazing happily at each other. For prostitutes, sexually exploited by men and treated as commodities, lesbian relationships provided an outlet for the

Women in a Brothel, 1893
Oil on cardboard, 60.3 x 80.5 cm
Szépmüvészeti Múzeum, Budapest

The Inmate of the Brothel, 1894
Oil on cardboard, 49 x 34 cm
Private Collection, New York

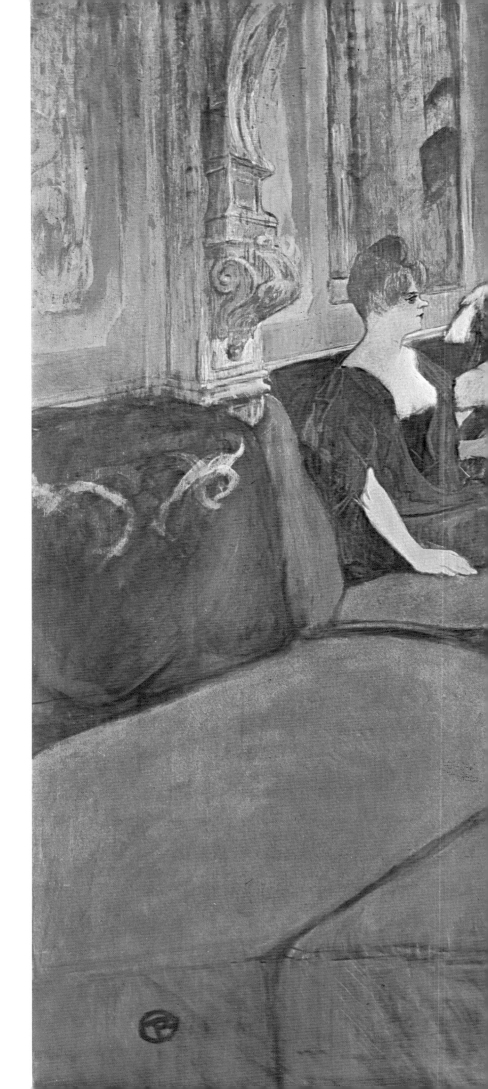

"And you imagine you're talking about love? You're only talking about what happens between the sheets... Love is something else..."
TOULOUSE-LAUTREC

The Salon in the Rue des Moulins, 1894
Oil on canvas, 111.5 x 132.5 cm
Musée Toulouse-Lautrec, Albi

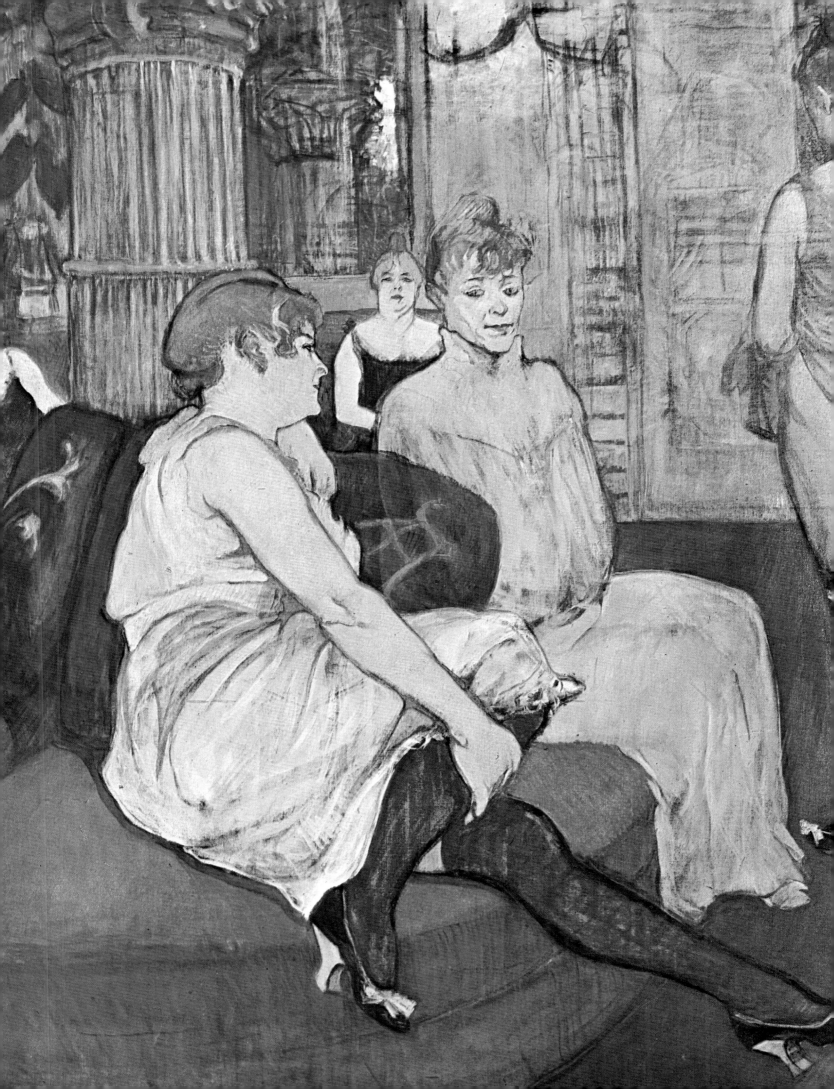

The Modern Judgement of Paris, 1894
Lithograph, 5.6 x 7.3 cm
Private Collection

"If a woman is simply a redhead, but really a redhead, a proper redhead — give her the full Venetian treatment!" TOULOUSE-LAUTREC

Woman Adjusting her Garter, 1894
Gouache on cardboard, 61.5 x 44.5 cm
Musée Toulouse-Lautrec, Albi

feelings of tenderness they too had. In formal terms, the picture's structure, tending to abstraction and with areas whose decorative values exceed their textural content, relates it to work done at the same period by the "Nabis", though Toulouse-Lautrec does not neglect his content in the way that Bonnard or Vuillard often did. The sparing but highly sophisticated colouring of this painting appears three years later in the lithographic cycle "Elles", also concentrating on life in the brothels.

In other pictures of whores (p. 68) Toulouse-Lautrec conveys the emotional relations of his models more unambiguously: the embraces and kisses and intimate chat of two women, often quite different in age and type, are presented without any reservations in all their human innocence. One or two large-scale individual portraits (p. 72) take their place in a grand artistic tradition. Toulouse-Lautrec was an admirer of painters of the early Renaissance such as Piero della Francesca and Domenico Veneziano, among whose masterworks were a number of female portraits. Rembrandt too affords examples of the kind of portrait that Toulouse-Lautrec, unusually for his time, took up in such works.

He had already produced first-rate work of this kind in his early Carmen portraits of the 1880s and the 1888 portrait of Hélène Vary (Kunsthalle, Bremen). When in 1893 he was asked to adorn the salon of a brothel in the Rue d'Amboise he hit upon the idea of providing portrait medallions in Louis XVIII style, which had the effect of unmasking the courtly pretentiousness of French style while also placing prostitutes in an exalted milieu which was at the same time satirized. In the individual portraits of prostitutes, Toulouse-Lautrec makes no distinction between his models and the "good citizens" who were their customers or affected superiority. In general, the girls felt flattered that "Monsieur Henri" wanted to portray them. One of them, Mireille, even brought flowers when she visited Toulouse-Lautrec's studio, which touched the artist. His comment on the girls was : "They have a good heart. True education is a matter of the heart, and that is good anough for me." Like his idol Degas, Toulouse-Lautrec was of course also fascinated by the basic earthiness of the prostitutes: "Professional models always seem to have been stuffed, whereas these girls are alive… I shouldn't dare offer them 100 sous for sitting for me, but God knows they're worth it. They loll and stretch on the divans like animals… They are utterly without affectation."

Around 1500 the Venetian Renaissance master Vittore Carpaccio had already painted a brothel picture (Museo Correr, Venice), a reproduction of which hung in Toulouse-Lautrec's studio. The French artist's most famous work may well be an allusion to Carpaccio's. After a number of preliminary studies, some of which seem fresher and more immediate than the final product, he painted "The Salon in the Rue des Moulins" (pp. 74/75), a very thoroughly executed piece by Toulouse-Lautrec's standards. We see a number of prostitutes waiting for customers, sitting lightly-clad on red velvet sofas; the woman in a pink gown on the right, probably the propietress of the establishment, seems an odd one out. She provides the artist with a contrast to his lolling, stretching animals. He has worked with a sure eye for faces and

Nude Woman Standing at the Mirror, 1897
Oil on cardboard, 63 x 48 cm
Haupt Collection, New York

physical positions. He was also exceptionally good at showing them routinely getting dressed (p. 77).

A number of nudes, unique in French art, round off Toulouse-Lautrec's brothel paintings in the late 1890s. "Nude Woman Standing at the Mirror" (right) is one of his least-known but most accomplished paintings and symbolically summarizes all his pictures of prostitutes. We see a whore standing in front of her reflection in a mirror; she is wearing the typical dark stockings, and holding the blouse she has just taken off. She stands revealed, the moment of truth has come; as Jean Cocteau once said, "Every day when I look in the mirror I see Death going about his business." We can view Toulouse-Lautrec's picture in the same way. The girl's body is still young and fresh, but for how much longer? What then? Who will still want the woman then? She will no longer be up to selling love (hinted at by the rumpled bed visible in the background).

It may be that this paintings, which we can certainly see in such symbolic terms, was inspired by baroque **vanity** pictures; but it was Toulouse-Lautrec's strength that his works resist being seen in one way only. The insensitive might see in this masterpiece no more than a delicate and accomplished nude of the kind that Degas, Renoir and Matisse made a French speciality, but we should not allow what looks at first sight like images of sensual serenity to distract our attention from Toulouse-Lautrec's message. These are pictures created by a wounded heart and a wasting body, where a spirit still alert intuits its coming end.

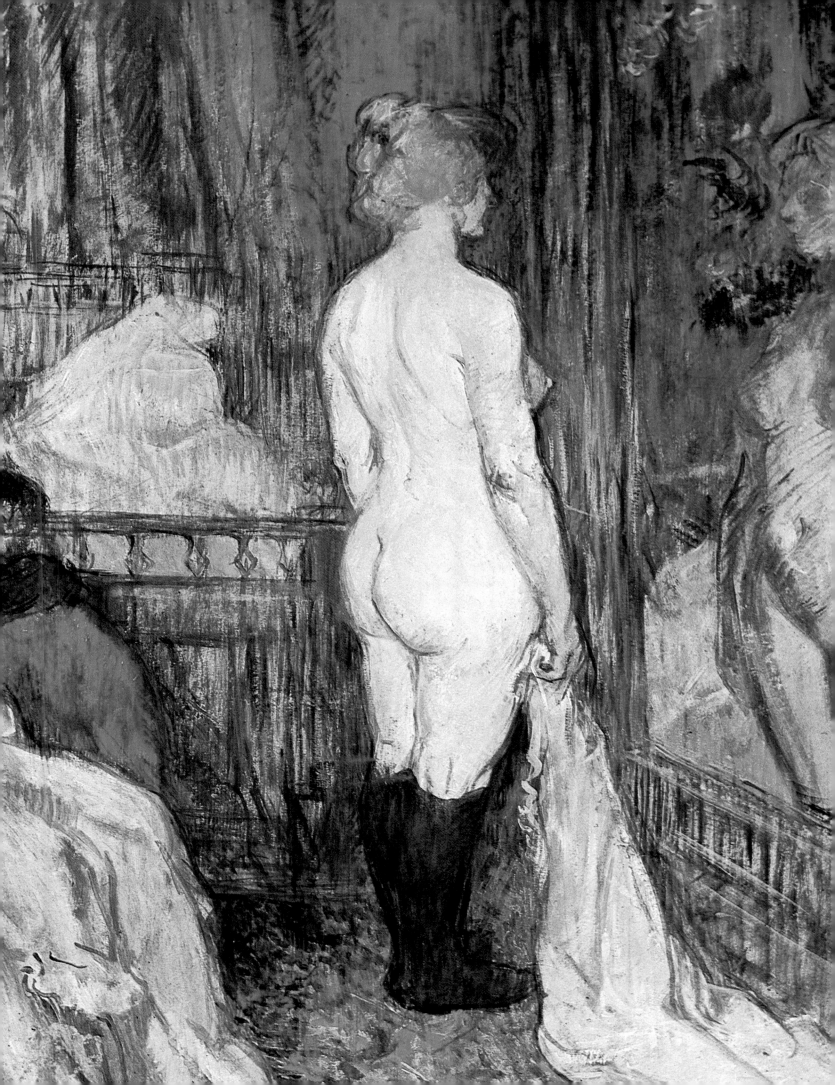

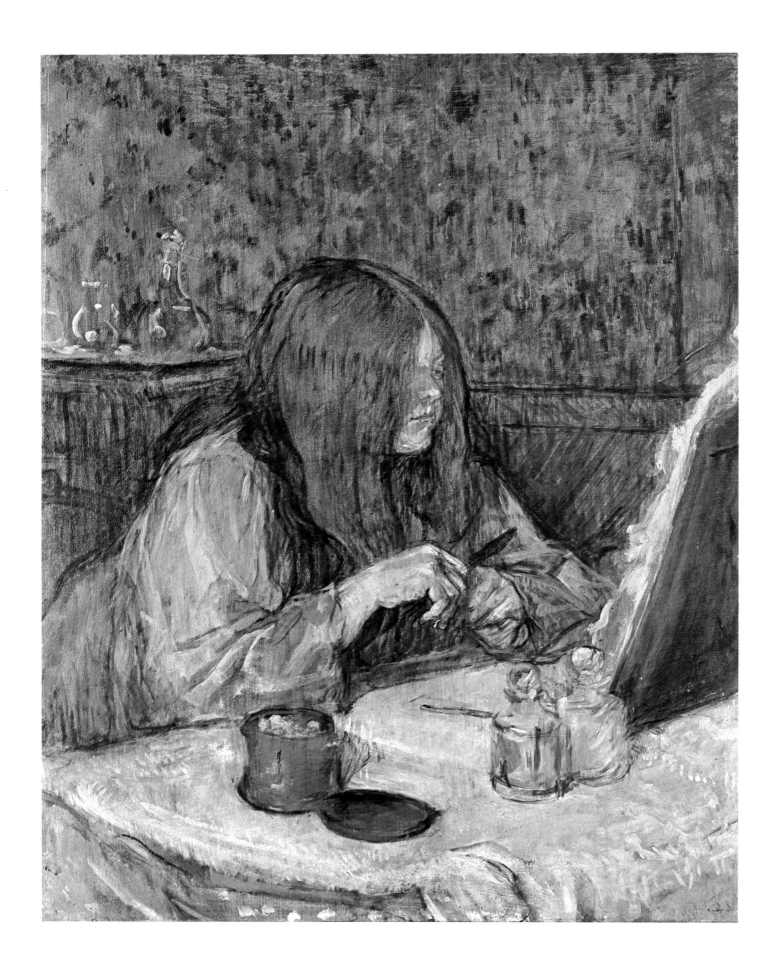

Mastery and Self-destruction
1899 - 1901

A whore looking into her mirror… How much more a picture like this expresses than all of Renoir's and Degas's paintings of women dressing put together! The subject, treated superficially by most other painters, has deeper significance in Toulouse-Lautrec's treatment (left). The composition and the melancholy import close the circle to his youthful self-portrait, with the still-life in the foreground on the dressing-table, the inward pause at an everyday task, the glance in the mirror. As in "Nude Woman Standing at the Mirror", painted two years earlier, what is celebrated here is neither beauty not eroticism but immutable transience. These women raise questions: Who am I? What will become of me? What is the point of it all?

It is no accident that these works were painted on the brink of Toulouse-Lautrec's decline. They may have been done with Dutch **vanitas** pictures in mind that he probably saw on two trips to Holland and which use symbolic props to indicate the vanity of all human endeavour. This imagistic expressivity, so totally beyond mere decorativeness or formality, marks Toulouse-Lautrec as an outsider in French art; his late work in particular, done in the space of two short years, anticipated the achievements of the Expressionism that was soon to follow in Germany. A muted minor-key note prevails in his artistic mastery.

Toulouse-Lautrec had for years been living beyond his physical means, and it began to catch up with him. Constitutionally he was in any case weak, and he had not spared himself, with his all-night bar-hopping, downing increasingly vast amounts of alcohol. From a certain time on, not even the warnings of friends or of his constantly worried mother helped. Nor was it possible to assist him by providing other amusement; indeed, the alcoholic had grown suspicious and often saw through plans and rejected them. He came to affront even his closest friends, and only succeeded in making his isolation all the greater. He took up with the worst kind of company: light women who drained the pleasure-seeker of his money, and some rather unsavoury men who served as his drinking companions. In the end this artist, intelligent and gifted though he was, let himself go and more or less deliberately sought his own downfall.

At the Circus: Clown, Pony and Baboon, 1899
Pencil and crayon, 35.5 x 25 cm
Art Institute of Chicago, Chicago

"One has to be able to put up with oneself." TOULOUSE-LAUTREC

LEFT:
Madame Poupoule Dressing, 1898
Oil on wood, 60.8 x 49.6 cm
Musée Toulouse-Lautrec, Albi

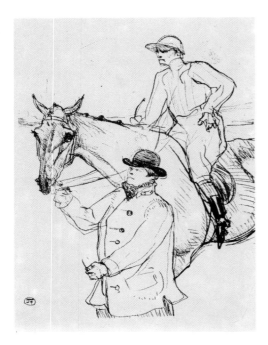

Jockey on his Way to the Scales, 1899
Monochrome lithograph, 38.5 x 28.2 cm
Musée Toulouse-Lautrec, Albi

"Lautrec loved animals too. The animals along the avenues of the Bois, the animals at the circus or in the menageries... He loved sport, all kinds of sport, and everything about sport." THADÉE NATANSON

The Jockey, 1899
Lithograph with oil and water colour, 51.5 x 36.3 cm
Private Collection

Toulouse-Lautrec's final years of life resemble a chronicle of gradual self-destruction. In addition to his inherited debility he had syphilis, which in his day was incurable. His friend, Dr. Henri Bourges, advised spells at the sea and other trips, to ease his illness. The 19th century saw many of its artists struck by syphilis, among them Franz Schubert, Friedrich Nietzsche, Manet, Gauguin and probably van Gogh. Toulouse-Lautrec drank more and more to dull his body and spirit, to numb the pain and to forget his lot as a man excluded from normal life. But the alcohol, to have the desired effect, needed to be consumed in ever greater quantities. It became a vicious circle. The artist's personality changed. He suffered from paranoid obsessions, became tyrannical and unpleasant, and devised devious ways of avoiding the means which well-wishing friends and relatives thought up to keep him from drink.

Then at the beginning of 1899 Toulouse-Lautrec collapsed in the street. In a state of delirium, he was taken (apparently at his family's request) to a mental hospital at Neuilly near Paris. Deprived of alcohol, he gradually recovered his senses, realised he was in an asylum, and flew into a rage, fearing he would be locked away for good. At the age of thirty-five, in this situation, he recalled the words Count Alphonse had written in his weak little son's falconry book, and sent his father a letter crying out for help: "Papa, this is your chance to act humanely. I have been imprisoned, but everything that is imprisoned dies!" His father, however shied away from his responsibility. Friends (Joyant especially) visited Toulouse-Lautrec, and again and again he requested help and freedom; but they hesitated to take over-hasty steps, and soothed their consciences by remembering the doctors' diagnostic warnings. The doctors, of course, had a vested interest in keeping a well-to-do patient in their hands as long as possible. In the end, Toulouse-Lautrec could see only one way out: he himself had to prove that he was once more in a normal condition. He asked Joyant for the tools of his trade: "Once I have done a certain number of drawings they will not be able to keep me here. I want to get out, they have no right to lock me up."

Working from memory, he did a series of drawings on the subject of the circus, on coloured chalk – drawings that are rather overworked by Toulouse-Lautrec's standards. But then, they were done primarily with the aim of convincing the Neuilly doctors that he had pulled himself together again; he was out to show that he was in command of his trade. Masterly as they are, these drawings, with their echoes of a subject he had liked at an earlier time, strike us as uncanny. The strong emphasis on shadows and his (not always successful) attempt to get the proportions of figures "right", as well as the presentation of clowns and animals shown in front of ranks of terribly empty circus seating, give us insight (his efforts at exactness notwithstanding) into his inner turmoil, the unsteady world he was now living in, his melancholy and desolation.

The Parisian press had meanwhile launched an ugly campaign against him. They had got wind of his confinement and were out to establish the nastiest of links between Toulouse-Lautrec's art and his

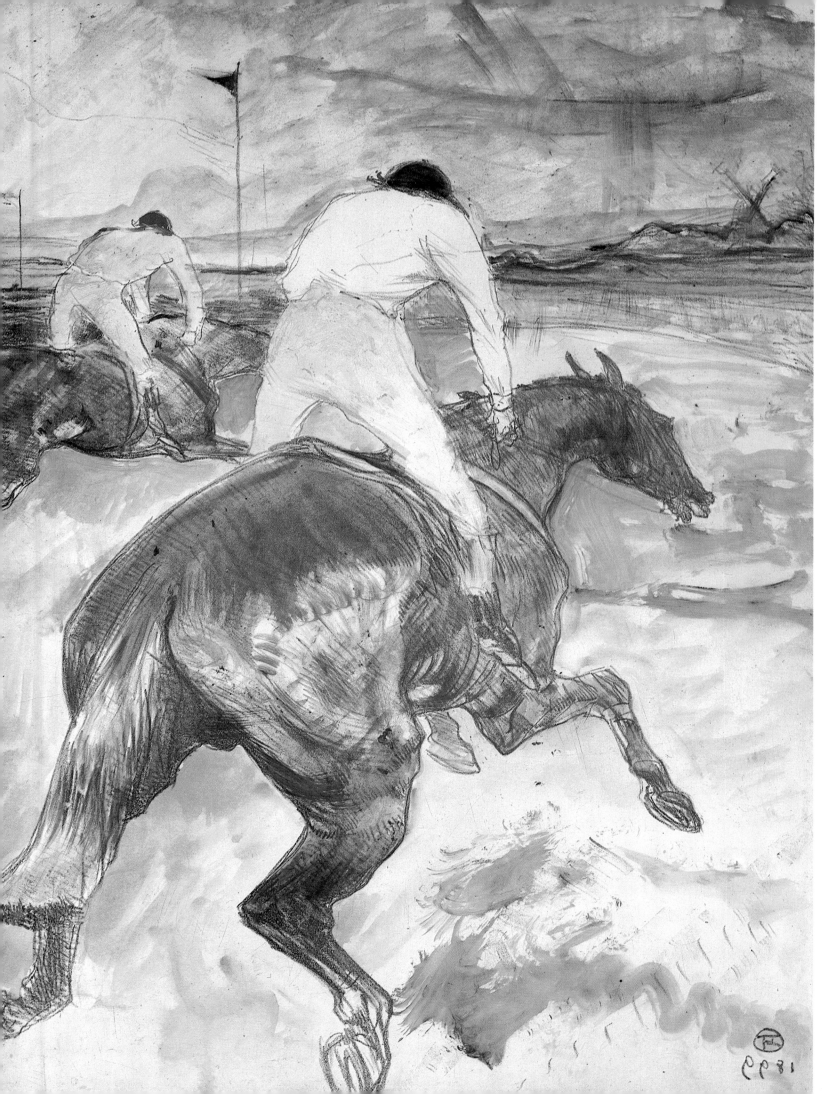

The English Girl from "The Star" at Le Havre, 1899
Red crayon, 62 x 47 cm
Musée Toulouse-Lautrec, Albi

"Let's go and see the puppets dance. They're really good, they're marvellous... No, don't worry about it, drinking doesn't do me any harm... What, I'm so close to the ground? What of it? I drink only the best. How can it be bad?" TOULOUSE-LAUTREC

The English Girl from "The Star" at Le Havre, 1899
Oil on wood, 41 x 32.8 cm
Musée Toulouse-Lautrec, Albi

mental condition. When he was discharged on 17th May, liberty was the finest present he could have been given. He felt he had "fled from prison" and told his friends repeatedly: "I bought my way out with my drawings."

Toulouse-Lautrec had been discharged on condition that he would not be left alone, for fear of a relapse. A distant relative from Bordeaux, Paul Viaud, volunteered to be his constant companion. After a short stay in Albi, Toulouse-Lautrec set off on his travels with Viaud. From Le Havre he wrote to Joyant, who by agreement was taking care of the artist's financial affairs and whom Toulouse-Lautrec therefore addressed ironically as his "guardian": "Dear Sir, we are glad to confirm that the art materials have arrived safely. I have done a red chalk drawing of an English girl in the 'Star' which I shall send off by registered mail tomorrow..." (left). "Dear Sir, yesterday I sent you a canvas showing the head of the barmaid at the 'Star', by registered mail. Please have it dried and framed. My thanks for the news of my finances. I hope my guardian is satisfied with his ward."

From an artistic point of view, Joyant had cause to be satisfied. "The English Girl from 'The Star' at Le Havre" (right) is a masterpiece of portrait art. Using relaxed but precise brush-strokes that betray no sign of his recent breakdown, he painted the image of the English barmaid in a seaport bar, a young creature who is open to life and carefree. The colouring is of a notable delicacy, with gentle shades of pink effecting the transition from the blue of the dress to the yellow of the girl's hair. The greens in her brightly-coloured blouse are taken up in the architectural background and varied with blues. The oil paint is applied thinly, in a linear and picturesque way; the painting is like a mosaic composed of different patterns of lines and dots. The effect is fresher and livelier than the red chalk drawing done as a preliminary.

Toulouse-Lautrec brought off a similar and arguably more significant achievement around the turn of the year 1899/1900 in his painting "In a Private Room at the 'Rat Mort'" (p. 87). We see an expensive bar, with a somewhat sketchy man cropped by the right edge, and his little lady friend, garishly turned-out, sitting at a set table behind a virtuoso still life. Bright and doll-like, the coquette seems almost to be a part of this arrangement of fruit – delicious enough to eat, as it were. The cherry red of her made-up mouth, and the yellow used for her face, re-appear in the pear of the still life. What gives life to the painting is not only the contrast of light and dark (stronger here than in his earlier work) but also the carefully thought-out balance of colour values: the red of that doll-like mouth suggestively provides the background too, with the effect that the warmer colour seems to be pushing the cooler colours of the figures and objects in front towards us.

Toulouse-Lautrec also painted a very fine late portrait of a milliner (p. 86) with whom he enjoyed an almost childish friendship. Here once again is the emphatic contrast of dark and light: we see a strawberry blonde young woman in profile, her eyes downcast and half closed, wearing a shimmering yellow green blouse, wholly absorbed in her

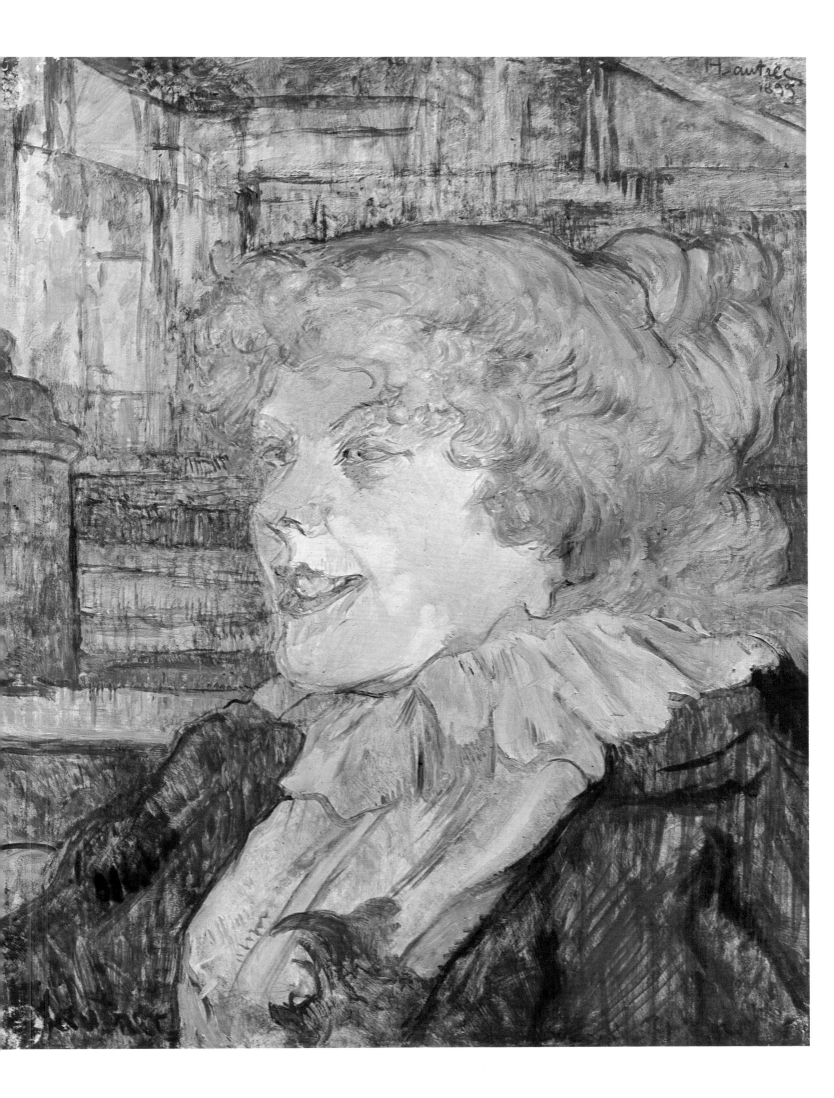

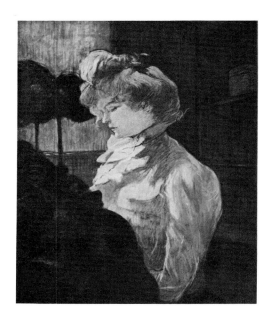

The Milliner, 1900
Oil on cardboard, 61 x 49.5 cm
Musée Toulouse-Lautrec, Albi

work, among dark hats on display and the rear wall with window. We are reminded of Jan Vermeer's dreamy girls standing at windows, though this picture, with its varied colour and the deeply moving mood of gentle sadness, is filled with tender introversion. It is a consolatory farewell. Some months later, before he set off on his last journey of all, Toulouse-Lautrec was to take his leave from the milliner for ever with a similarly calm serenity: "Let us embrace, you will not be seeing me again. When I am dead I shall have Cyrano's nose."

In the last but one year of his life, Toulouse-Lautrec also painted his friend Joyant, in yellow oilskin and sou'wester, standing aboard a sailing-boat, his gun raised for duck-shooting (p. 88). Against a sketchy background that allows the grain of the wood on which the picture was painted to show through, the stoutly-built man, seen almost full-length and from the side, is established in bold yellow and chestnut brush-strokes. Only his pinkish-yellow face and purplish-red hands break with the overall colour scheme. This kind of painting, explosive and rapid and uncorrected afterwards, might have been inspired by "Professor" Hals, from whom Toulouse-Lautrec had occasionally taken "lessons" in Holland. A certain wildness in the style marks this work out from the draughtsmanly hatching and reticent colouring in earlier paintings. Perhaps this rapidity of execution was dictated by the slackening of his constitutional powers: sheer lack of endurance and patience caused Toulouse-Lautrec to slap his work down quickly, and in this way he anticipated much that was later to come in the Expressionist and subsequent movements in modern art – anticipated and, in terms of quality and accuracy, excelled. Knowing of the collapse of his health, critics sometimes rate Toulouse-Lautrec's late work lower and find it wanting; but in fact they are wrong to do so. During the last stage of illness, the artist drew upon reserves of creative energy and went back to the very heart of his talent and concerns, offering us a distillation of all he had seen and felt.

In the winter of 1900/1901 Toulouse-Lautrec rented a studio and apartment in Bordeaux, his companion's home town. His passion for the theatre reawoke with visits to Jacques Offenbach's operetta "La Belle Hélène" and Isidore de Lara's opera "Messalina", for a last time. In a letter to Joyant in Paris he wrote: "My dear Maurice, have you seen any photos, good ones or bad, of Lara's 'Messalina'? The show quite engages me; and the more I know about it, the better my work will go." Plainly he was intending to paint various pictures showing this opera; six of the "Messalina" series have survived, all done on canvas. Though they vary in quality, all of them are attractive in their colouring and unconventional in their approach to form. It is possible that these pictures draw not only on sketches and recollections of performances but also on photographs that his friend Joyant perhaps sent him. This might explain unusual features in the composition. Though no doubt Toulouse-Lautrec, normally an artist who valued the spontaneity of impressions, would have had reservations about such a process of creation, it must have

**In a Private Room at the "Rat Mort",
ca. 1899/1900**
Oil on canvas, 55 x 45 cm
Courtauld Institute Galleries, London

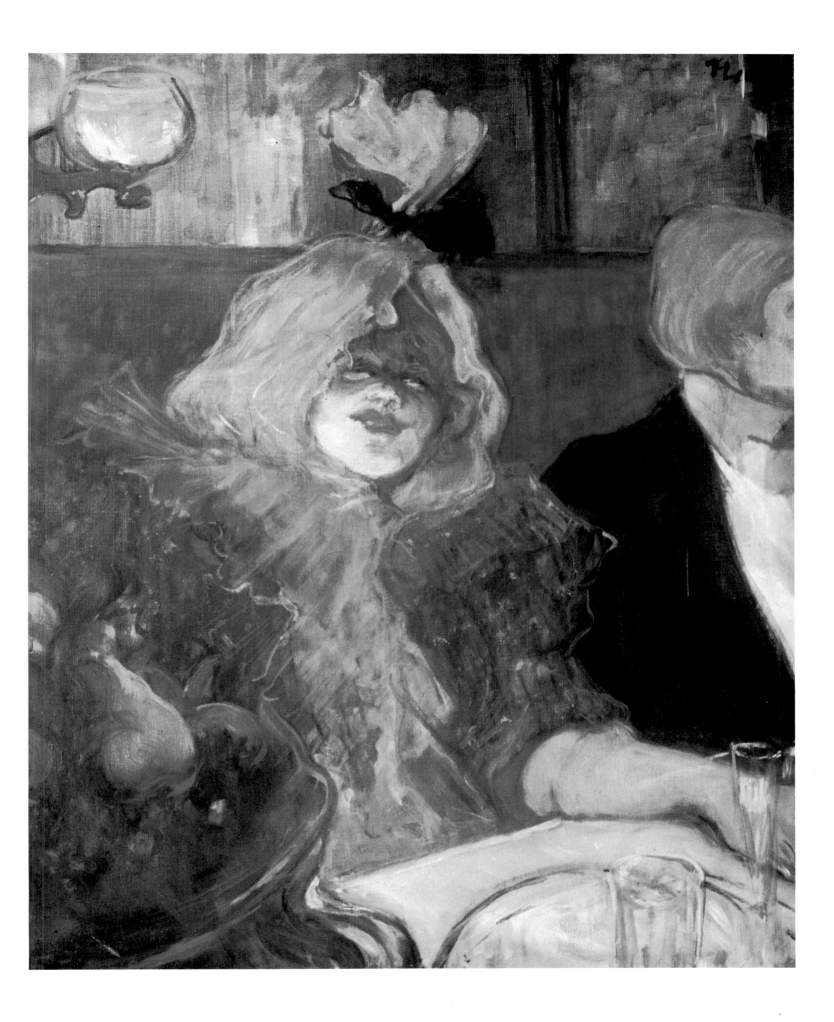

had the advantage of helping the weakened memory of the painter, and enabling him to concentrate on technique and colour values.

The Zurich picture, "Messalina with two extras" (p. 91), is a particularly virtuoso piece of craftsmanship, wholly thriving on the interplay of the three prime colours, blue, red and yellow. Here once again the red background has the effect of pushing the cooler foreground further forward. This painting also shows a new mastery in the loose, sketchy application of paint that replaces the earlier dominance of the line in Toulouse-Lautrec's art: the great draughtsman, significantly no longer at work on lithographs, emerges as a great expressive painter in his last paintings.

After a final visit to Paris, to clear up his studio and put his artistic estate in order and sign a few things, and destroy others, Toulouse-Lautrec travelled to the sea as he did every year. In mid-August, in Taussat, he suffered a stroke which left him partially paralysed. Countess Adèle, who knew that he was going to die, took him to Château Malromé on 20th August. During a brief period of recovery, Toulouse-Lautrec painted his last and (in terms of format) largest surviving picture (Museu del Arte, São Paulo), which he conceived as a mural for a room in the castle. It shows his companion Viaud, in an admiral's uniform and wig in 18th century style, with the sea in the background and a frigate in trouble in a gale out on the horizon. The background of the picture is unfinished and there are trickles where the paint has run (a visual effect which has become ugly normal practice among the Neo-Expressionists of our own time).

His family was well aware of the seriousness of the situation; and towards the end Toulouse-Lautrec also abandoned his lifelong self-protective mask of irony and sarcasm. On 9th September 1901 at 2.15 in the morning, not yet aged 36, Henri de Toulouse-Lautrec died, in full possession of his faculties, in the presence of his parents, his companion Viaud, and his cousin Gabriel, who had hurried to his deathbed at the painter's express wish.

At the time of his death, Toulouse-Lautrec was well-known, mainly through his posters, but the calibre of his artistic achievment was not merely disputed but was in fact wholly dismissed by the official art world for many years. As early as 1902, his mother founded a complete collection of the graphic art, along with a great many trial printings, in the Bibliothèque Nationale in Paris. After lengthy deliberation the Louvre accepted a Toulouse-Lautrec as a gift. In 1904 the family gave four pictures to the Toulouse Museum. In 1914 more of his works were made over to the Louvre under the will of an eminent collector, Camondo. Abroad, especially in Scandinavia and Germany, collectors and museums gradually began acquiring Toulouse-Lautrecs. Then in 1922, with the co-operation of the family and on the initiative of Joyant (who some years later wrote the first and basic biography of the artist), the Musée Toulouse-Lautrec was opened at Albi, and remains to this day the most important collection of his works.

Toulouse-Lautrec was always overshadowed by his great

Head of an Old Man (Patient at Neuilly Hospital), 1899
Coloured crayon, 35 x 30.4 cm
Musée Toulouse-Lautrec, Albi

"Mama, only you! Dying is damned hard!"
TOULOUSE-LAUTREC's last words

Maurice Joyant, 1900
Oil on wood, 116.5 x 81 cm
Musée Toulouse-Lautrec, Albi

**Mademoiselle Cocyte in
"La Belle Hélène", 1900**
Drawing for the watercolour, 40 x 29 cm
Musée Toulouse-Lautrec, Albi

**Messalina with two extras,
ca. 1900/1901**
Oil on canvas, 92.5 x 68 cm
E.G. Bührle Collection, Zurich

contemporaries Cézanne and van Gogh, but he need not fear comparison. Unlike other Post-Impressionists who are today no longer so highly rated as was the case even a few years ago – Gauguin or Seurat, for instance – Toulouse-Lautrec's reputation is still growing firmer. What distinguishes his art is not the supposed frivolity that alienated conservative art-lovers and in some quarters is still thought the basis of his work, but an incomparable capacity for empathy. Nowadays Toulouse-Lautrec's great significance as an artist of humanity is finally being assessed in exhibitions and books; Toulouse-Lautrec the lithographer and poster-artist has (unjustly) been rated above Toulouse-Lautrec the painter, but there are signs that hidden treasures are now being discovered among his 600-odd paintings.

He was reluctant to theorize about art, but he once made a comment to his cousin Gabriel that revealingly indicates his creative approach: "The first human being to invent a mirror put it upright, for the simple reason that he wanted to look at himself full-length. A mirror of that kind is all well and good, because it is useful and need be nothing more than useful. To invent it was a necessity, and everything that happens from inner compulsion is good, and justified. Later, other people came and said: Up till now people have set up their mirrors perpendicularly without ever wondering why they did so. They found that mirrors can be put horizontally on their sides – naturally – though the question is whether there is any point in doing so. They did it because it was novel, and it was the novelty that appealed to them; but nothing is ever beautiful merely because it is novel. In our time there are many artists who go for novelty, and see their value and justification in novelty; but they are wrong – novelty is hardly ever important. What matters is always just the one thing: to penetrate to the very heart of a thing, and create it better."

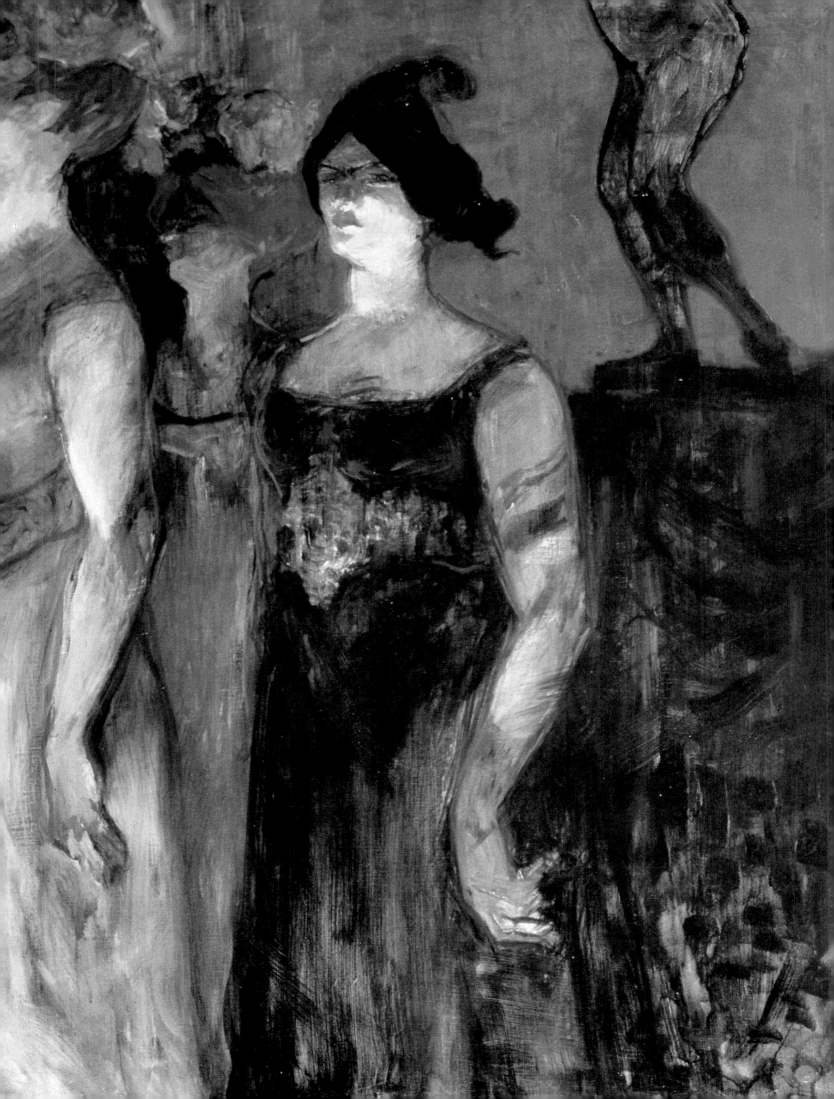

Henri de Toulouse-Lautrec 1864 - 1901: A Chronology

1864 Henri-Marie-Raymond de Toulouse-Lautrec-Monfa is born on 24th November at the Hôtel du Bosc at Albi, the eldest son of Count Alphonse de Toulouse-Lautrec-Monfa and his wife, Countess Adèle-Zoë-Marie-Marquette Tapié de Celeyran. His parents are first cousins.

1868 His brother Richard-Constantine, born on 28th August 1867, dies at the age of one. Henri grows up on the family estates in the south of France and at Albi, as well as Céleyran. From 1868 his parents are separated.

1872 Countess Adèle with Henri in Paris. Living at the Hôtel Parey, Cité du Rétiro 5. Henri goes to the highly thought-of Lycée Fontanes (later Condorcet) along with his cousin Louis

Pascal and Maurice Joyant, who is later to be his closest friend, dealer, and biographer. Sketches and caricatures in school exercise books. Contact with painter friends of his father's; the deaf mute René Princeteau, specialist in paintings of animals, is particularly helpful.

1875 Return to the family home, Because of his poor health, Henri is educated privately.

1878 Henri breaks his left thigh-bone in Albi. He convalesces at Amélie-les-Bains and Nice. At Barèges he strikes up a friendship with Etienne Devismes, for whom he illustrates a tale three years later.

Young Henri, nicknamed "petit bijou", at the age of about three

1879 Henri breaks his right thigh-bone at Barèges. From this time on, both legs stop growing.

1880 In need of therapeutic relaxation, he spends most of his time drawing and painting. Convalescence at Nice.

1881 In Paris in July, Henri fails his school-leaving examinations, but passes them in November when he re-takes them in Toulouse. Then in Paris with Princeteau. His decision to become a painter is supported by painter friends of his father's.

1882 Joins Léon Bonnat's Paris atelier. When it is closed he becomes Fernand Cormon's student in September. Among his fellow-students are Henri Rachou, René Grenier, Eugène Boch, Charles Laval,

The artist's father: Count Alphonse-Charles-Marie de Toulouse-Lautrec-Monfa wearing a Scottish costume

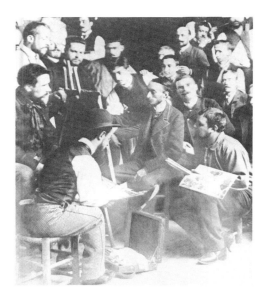

Toulouse-Lautrec (foreground left) in the studios of Fernand Cormon (at the easel), ca. 1885

François Gauzi, Louis Anquetin. He paints "Young Routy at Céleyran" (p. 13).

1883 Countess Adèle buys Château Malromé near Bordeaux; from this time Toulouse-Lautrec normally spends the late summer there after his annual spell by the sea (he is a keen sailor). Academic studies.

1884 Moves to Montmartre. First he lives in Lili and René Grenier's house at Rue Fontaine 19, where Edgar Degas has a studio. Increasingly he leaves academic approaches behind. The young Emile Bernard joins Cormon's studio. Toulouse-Lautrec exhibits in a group show at Pau, for the first time. Paints "Fat Maria" (p. 14) and the Carmen portraits (p. 52).

Because his head was over-sensitive, Toulouse-Lautrec would often wear a hat indoors. Ca. 1894

Posing cross-legged on an Arabian armchair

1885 He frequents clubs and bars in his quarter ("Elysée Montmartre", "Moulin de la Galette") and is a welcome guest at Aristide Bruant's cabaret club "Le Mirliton", where he exhibits paintings. Stays with Anquetin in Etrepagny and with the Greniers in Villiers-sur-Morin. Takes an apartment at Henri Rachou's, Rue Ganneron 22. "Portrait of Emile Bernard" (Tate Gallery, London).

1886 At Cormon's he meets and becomes friends with Vincent van Gogh. Summer at Villiers-sur-Morin, Malromé, Arcachon and Respide. In the autumn,

Forty winks after lunch

Drinking wine with friends in the garden of the Moulin de la Galette

Toulouse-Lautrec leaves Cormon and rents a studio at 27 Rue Tourlaque, at the corner of Rue Caulaincourt. He meets Suzanne Valadon, who is both his model and lover. First drawings published in magazines.

1887 Takes an apartment together with Dr. Henri Bourges at Rue Fontaine 19. Exhibits in a group show in Toulouse (using the anagram pseudonym "Treclau"). Together with van Gogh, Anquetin and Bernard he founds cloisonnism. Studies Japanese coloured woodcuts. His friends exhibit in cafés and restaurants. "Portrait of Vincent van Gogh" (p. 18).

1888 In February exhibits with the "Vingt" in Brussels. Theo van Gogh buys "Rice Powder" and takes other works on

"Monsieur Toulouse painting Monsieur Lautrec-Monfa." Photo-montage, ca. 1890

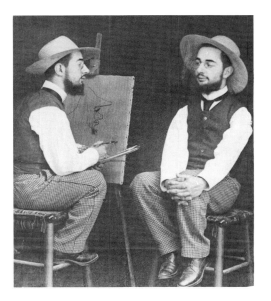

Toulouse-Lautrec in 1892

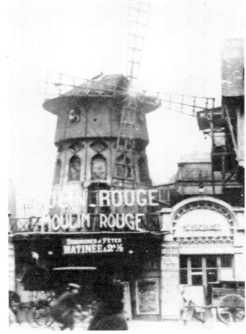

The Moulin Rouge at the Place Blanche. Ca. 1890

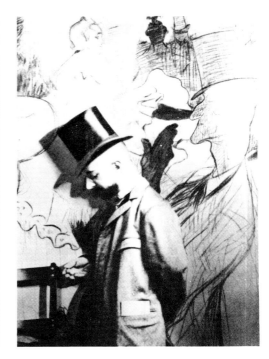

Toulouse-Lautrec, head shaven posing as Valentin-le-Désossé in front of a sketch for the Moulin Rouge poster. Ca. 1891

commission for Goupil. Autumn at Villiers-sur Morin. Separation from Suzanne Valadon. "Cirque Fernando: The Equestrienne" (p. 20).

1889 From now on he exhibits almost every year in the Salon des Indépendants and in the Cercle artistique et littéraire Volnay. He paints a series of portraits in "Père" Forest's garden in Montmartre. The "Moulin Rouge" is opened and

The artist with a model in his studio with his painting "The Salon in the Rue des Moulins" and other pictures. Ca. 1894

Toulouse-Lautrec becomes a regular. "At the Moulin de la Galette" (p. 26)

1890 Travels to Brussels with Paul Signac and Maurice Guibert for the opening of the "Vingt" exhibition. His school-friend Joyant becomes Theo van Gogh's successor as manager of Goupil's. Summer vacation at the seaside resort of Taussat and then in Spain. "Marie Dihau at the Piano" (p. 23), "At the Moulin Rouge: The Dance" (p. 27).

1891 Moves with Bourges to the house next door (Rue Fontaine 21). His favourite

cousin Gabriel Tapié de Céleyran comes to Paris to study medicine. Joins an Impressionist and Symbolist exhibition at Le Barc de Boutteville. "A la Mie" (p. 21). First printed graphic works, including the Moulin Rouge poster (p. 28).

1892 Travels to Brussels and London. Late summer in Taussat. Posters for Bruant (p. 33) and Jane Avril. Series of

With Charles Zidler, manager of the Moulin Rouge, in front of Jules Chéret's Moulin Rouge poster. Ca. 1891

Maurice Joyant carrying his friend Henri on board ship at Crotoy

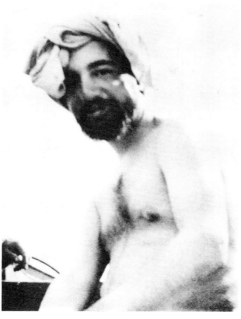

Taking a breather on the deck of the "Cocorico", after a swim

With his married friends Thadée and Misia Natanson at the seaside resort of Etretat. Ca. 1896

lithographs. "The Englishman at the Moulin Rouge" (pp. 48/49).

1893 First major solo exhibition at Goupil's. Exhibits with the "Vingt" in Brussels again. Stays with Bruant in Saint-Jean-les-Deux-Jumeaux. Takes an apartment in the building where he has his studio. Countess Adèle moves to the Rue de Douai nearby. Poster for the "Jardin de Paris" (p. 39). Greatly interested in theatre; also lives and paints in a brothel. Joint exhibition with the "Peintre-Graveurs".

1894 New apartment at Rue Caulaincourt 27. Travels to Brussels, Harlem and Amsterdam (with Anquetin). Exhibits with the Salon de la Libre Esthétique in Brussels, and at a show in Toulouse. In summer trips to Spain and then Malromé. Two stays in London. First album of Yvette Guilbert lithographs. The cultural journal "La Revue Blanche" attracts not only Toulouse-Lautrec but also the "Nabis" (among them Pierre Bonnard, Edouard Vuillard, Félix Vallotton). For a time he lives in a brothel. "The Salon in the Rue des Moulins" (pp. 74/75).

1895 Moves once again, to Rue Fontaine 30. Travels to Brussels for the Libre Esthétique exhibition. In London he meets Oscar Wilde and James Whistler, and exhibits in a show of posters. Trips to northern France; from there he travels by sea via Bordeaux to Lisbon ("The Passenger in Cabin 54", p. 42). Returns via Spain. Decorations for La Goulue's fairground booth (pp. 58/59); posters for May Belfort and May Milton.

1896 Exhibition at Joyant's. Le Havre, Bordeaux, Arcachon. Travels to Brussels, where he meets Henry van de Velde. Villeneuve-sur-Yonne, Spain, Arcachon. Visits the castles of the Loire. The "Elles" album of coloured lithographs (p. 44).

1897 Exhibits with the Libre Esthétique. New studio at Rue Frochot 5. In the early summer with Maxime Dethomas in Holland, afterwards at Villeneuve-sur-Yonne. Increasing problems with alcohol. "Nude Woman Standing at the Mirror" (p. 79).

1898 Exhibits at Goupil's London studio. Because of his growing health

problems his output declines in terms of quantity, though not of quality. Summer in Arromanches and Villeneuve-sur-Yonne. The second album for Yvette Guilbert is published in London. Nine etchings.

1899 Illustrations for Jules Renard's "Histoires Naturelles". After a breakdown he is confined for three months to an asylum at Neuilly. A polemical campaign against Toulouse-Lautrec is launched in the newspapers. Draws a circus series from memory (p. 81). After he is discharged he recovers on the coast of Bordeaux and at Le Havre. In spite of Paul Viaud's watchfulness, Toulouse-Lautrec's alcohol intake goes up again. Evolves his late style: "The English Girl from 'The Star' at Le Havre" (p. 85), "In a Private Room at the 'Rat Mort'" (p. 87).

1900 Money squabbles with his family. Exhibitions in Paris and Bordeaux. Protracted spell by the sea in summer. Winter in Bordeaux. "The Milliner" (p. 86), "Maurice Joyant" (p. 88).

1901 Theatre visits in Bordeaux (six pictures based on "Messalina", (p. 91). Signs of paralysis in his legs. From mid-April he spends a last three months in Paris, putting his affairs in order, then returns to the sea. After a stroke in Taussat he is paralysed on one side. On 20th August he removes to Malromé, where he dies on 9th September. He is buried in Saint-André-du-Bois; the body is later transferred to Verdelais. Final pictures: "The Medical Examination", "Admiral Viaud".

Art books from Benedikt Taschen

In this series:
Arcimboldo, Bosch, Chagall, Dalí, Degas, Ernst, Gauguin, van Gogh, Hopper, Kahlo, Kandinsky, Klee, Klimt, Lempicka, Lichtenstein, Macke, Marc, Matisse, Miró, Munch, Picasso, Rembrandt, Renoir, Rousseau, Schiele, Toulouse-Lautrec, Turner, Warhol

Benedikt Taschen Verlag GmbH, Hohenzollernring 53, D-50672 Köln